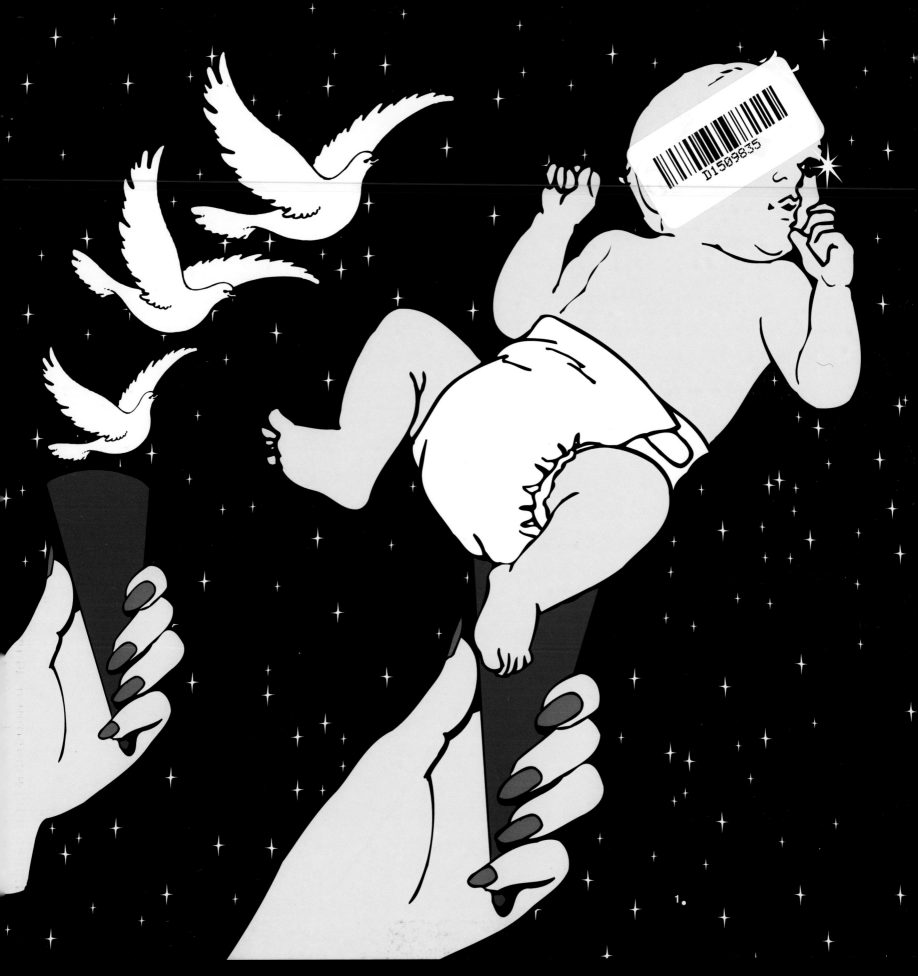

Your whole life has been leading up to this point.

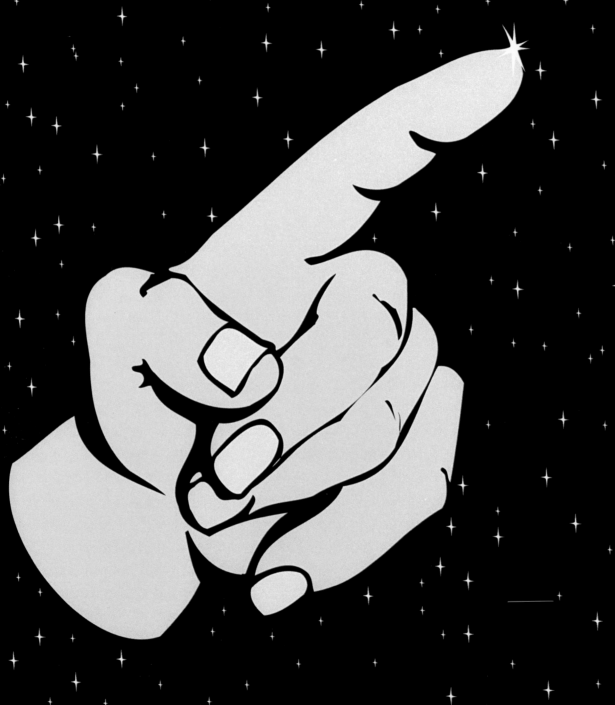

Donny Miller

Beautiful People
with Beautiful Feelings

Donny Miller

Abrams Image
New York

1.

Introduction

Life can be so ridiculous and this book proves it.
I have explored the embarrassment of being human. A painful process we all face,
presented here in an easy-to-read, easy-to-understand format.

The following page contains an exercise designed to give you everything in life.
Draw a healthy relationship, a new automobile, money, a new house, a perfect body,
beautiful food, an exotic animal–anything you want. Start anywhere. Finish anywhere.

Remember, you can have anything. You just have to think it.

Just kidding, life isn't that simple.

 Donny

What do you see?

This book is dedicated to my mother and father
and Baby Snoopy.

Thanks to Bud Rambo, Paul Costuros, Ashley Hibbs,
Curtis Lindersmith, Eli Bonerz, X-Large Clothing,
Carah Von Funk, Christa Hall, Ben Clark,
Erin loves Daniel Pipski and Tamar Brazis.
Without them, this book would not be in your hands.

Editor: Tamar Brazis
Production Manager: Kaija Markoe

Library of Congress Cataloging-in-Publication Data has been applied for.
ISBN 0-8109-4916-4

Printed and bound in China
10 9 8 7 6 5 4 3 2 1

HNA ▮▮▮▮▮
harry n. abrams, inc.
a subsidiary of La Martinière Groupe

115 West 18th Street
New York, NY 10011
www.hnabooks.com

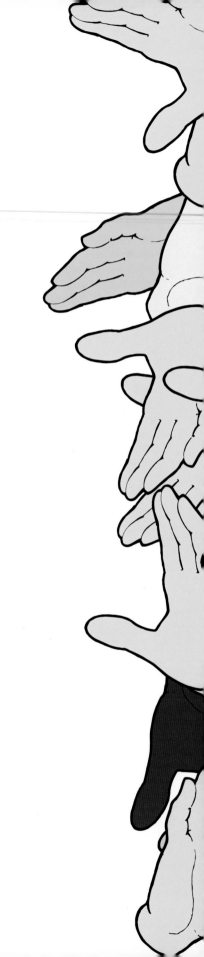

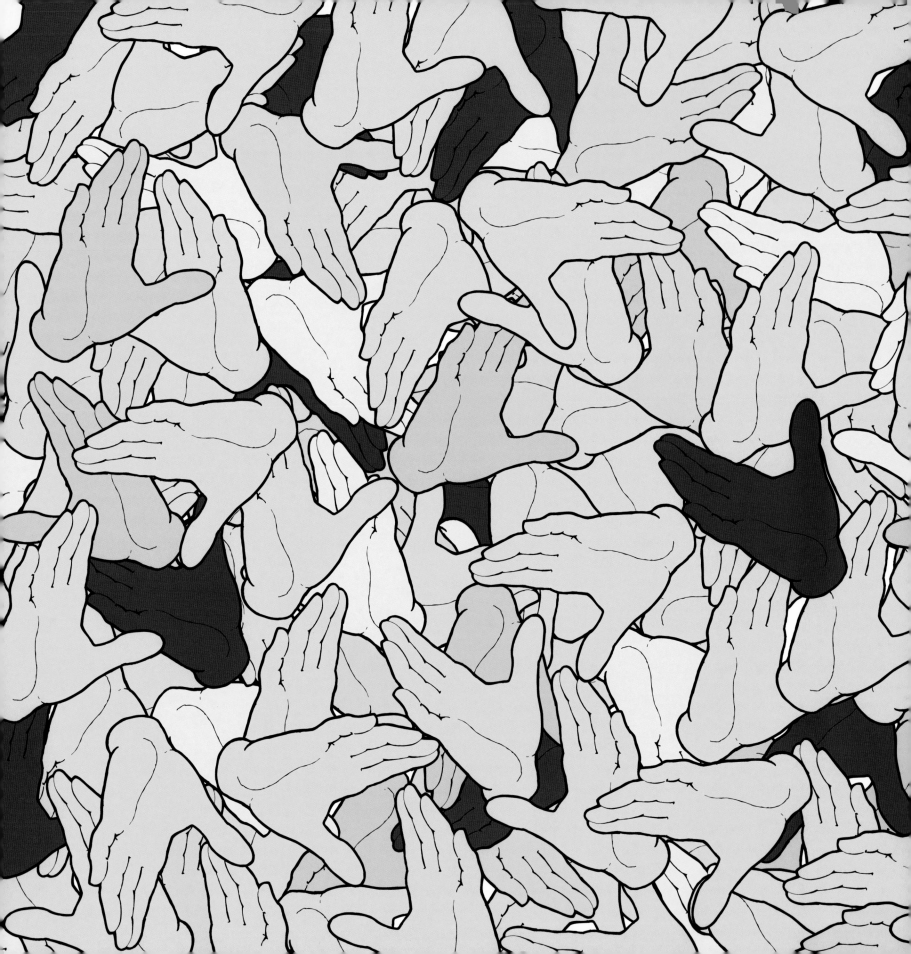

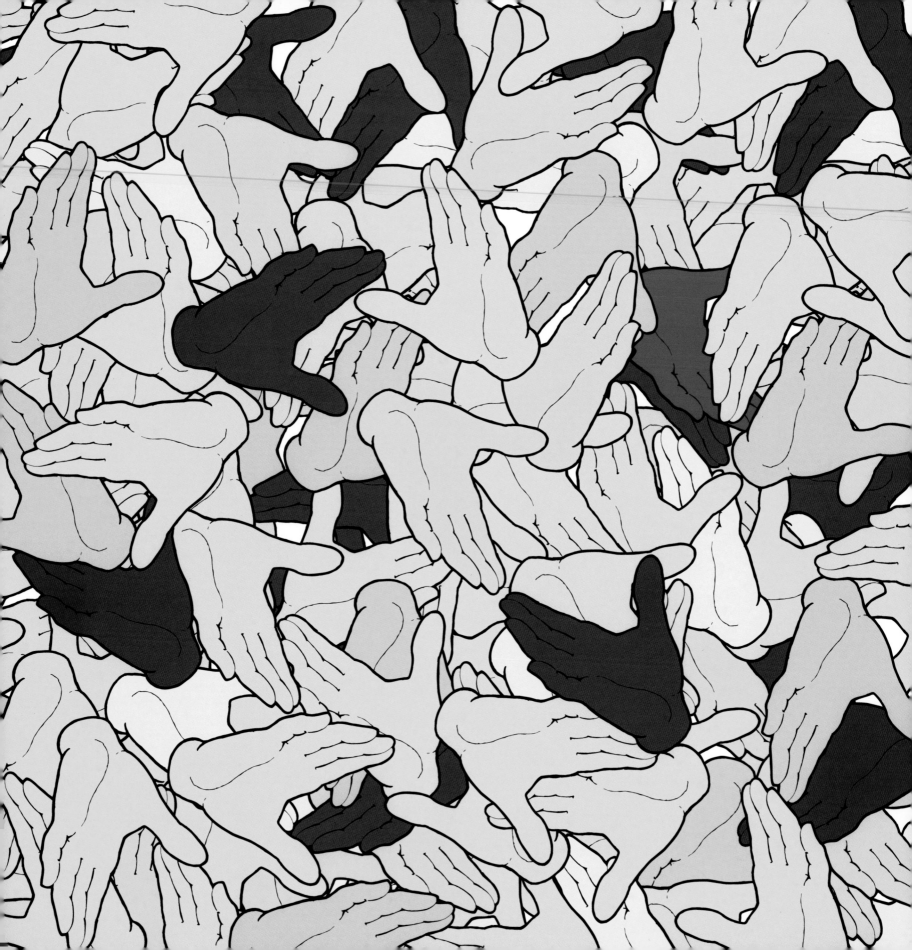

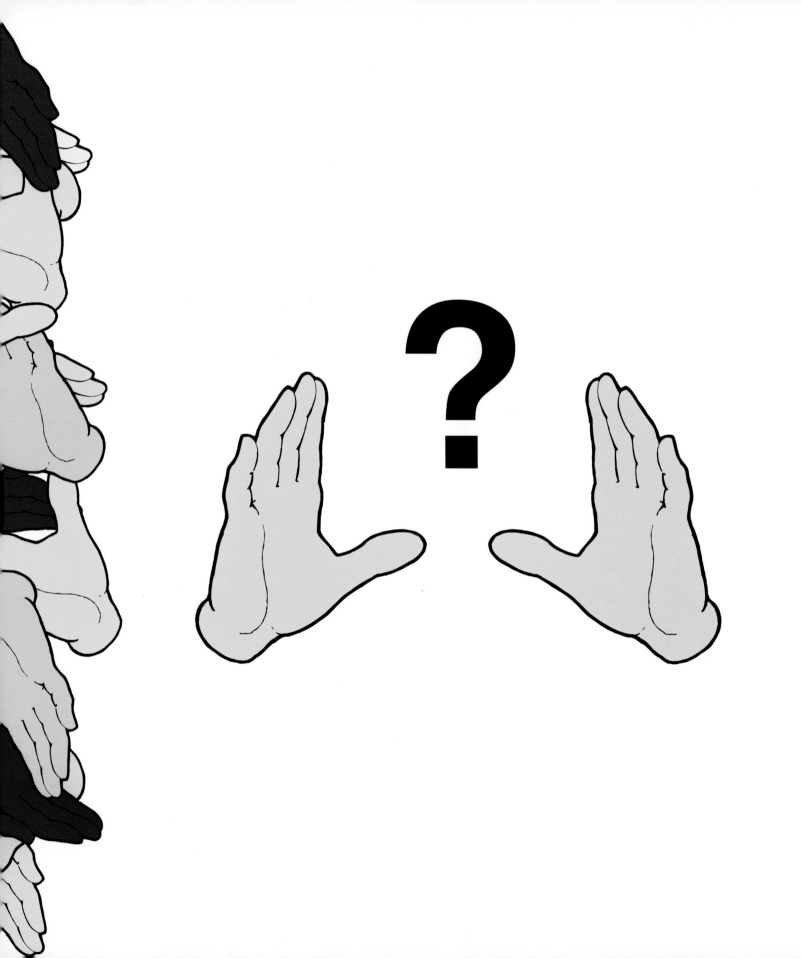

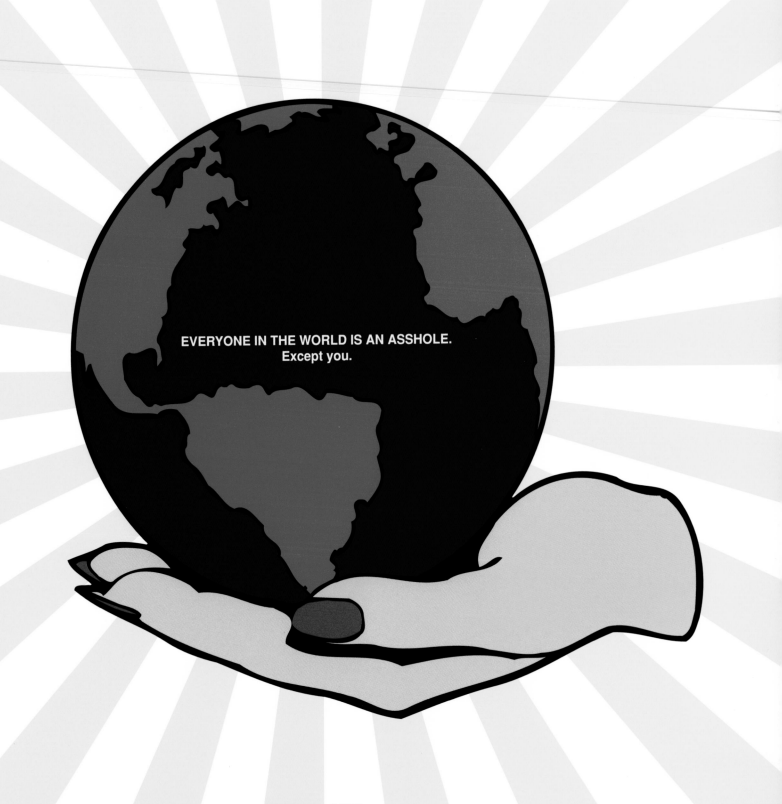

EVERYONE IN THE WORLD IS AN ASSHOLE.
Except you.

Donny Miller

The hand of God.

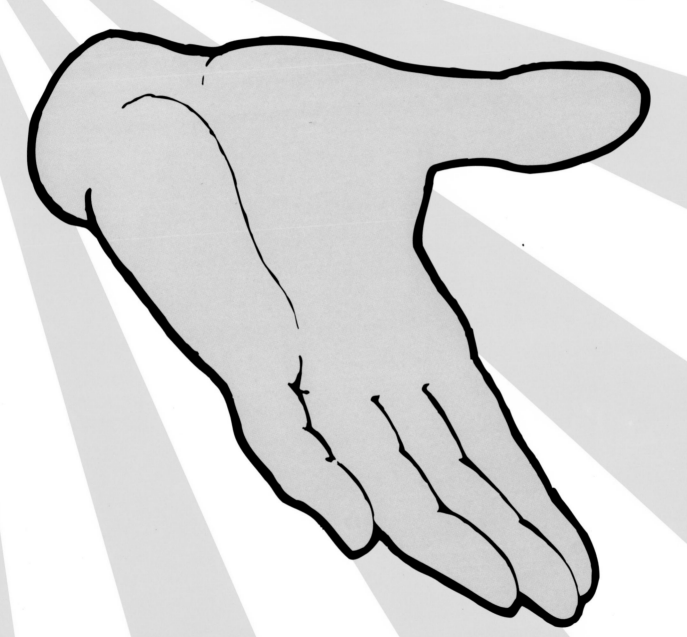

God is white, by the way.

Donny Miller

The hand of Satan.

Satan wears red make-up, by the way.

Donny Miller

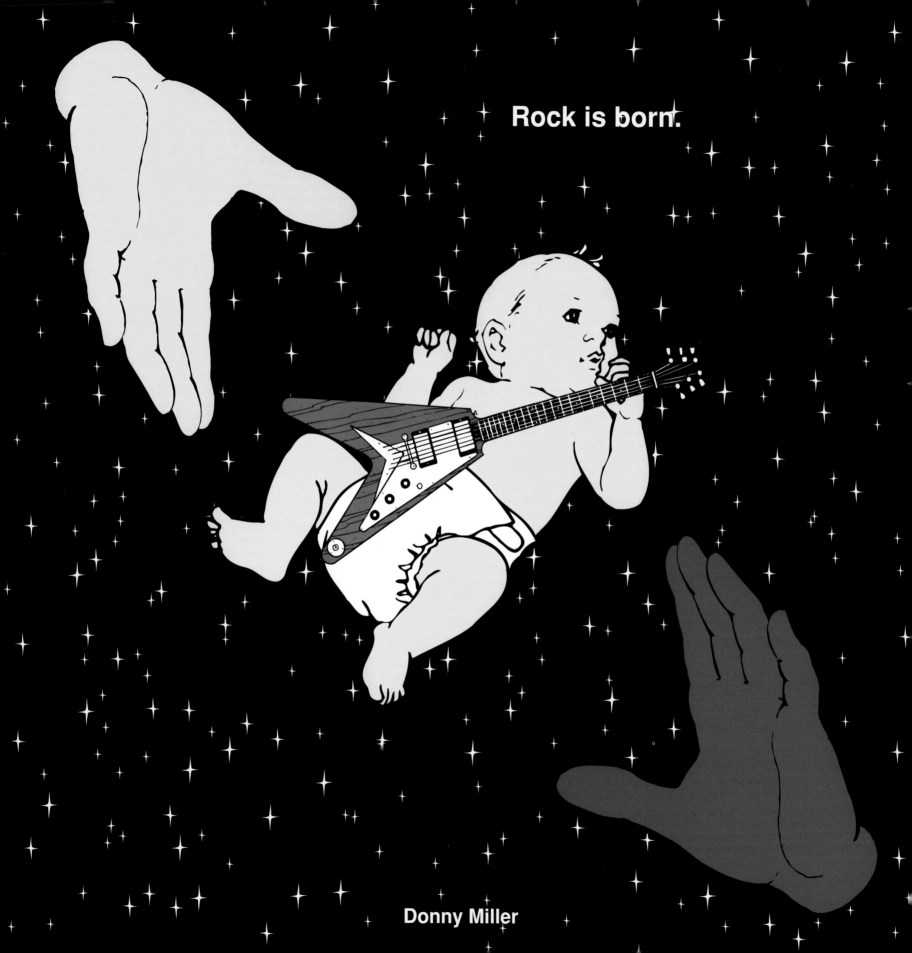

Rock is born.

Donny Miller

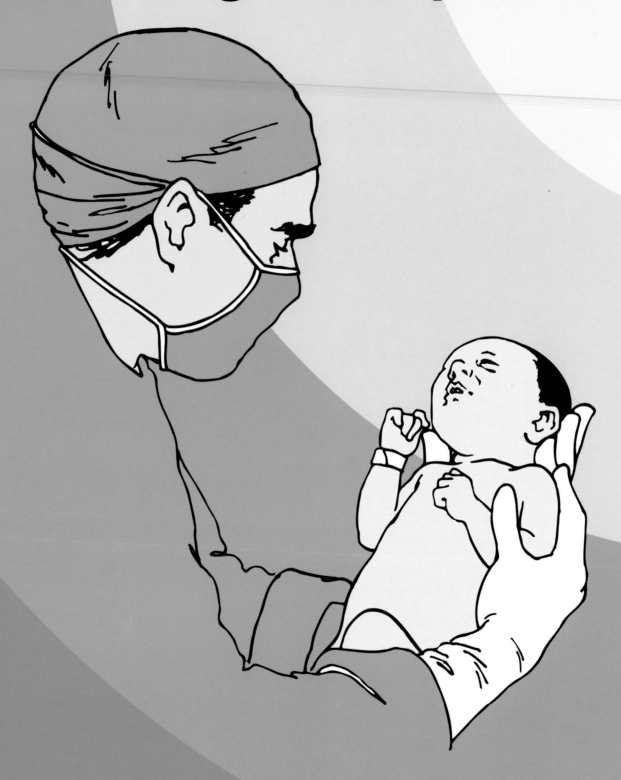

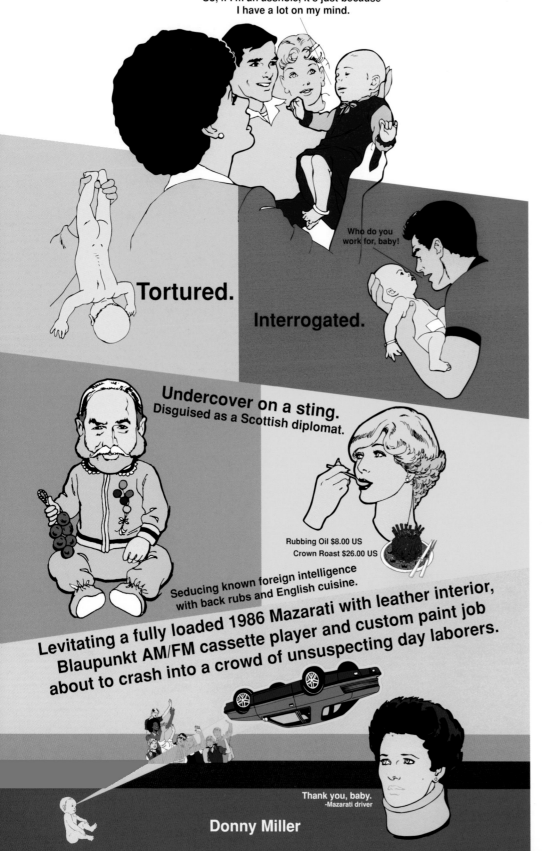

Art can make you think.

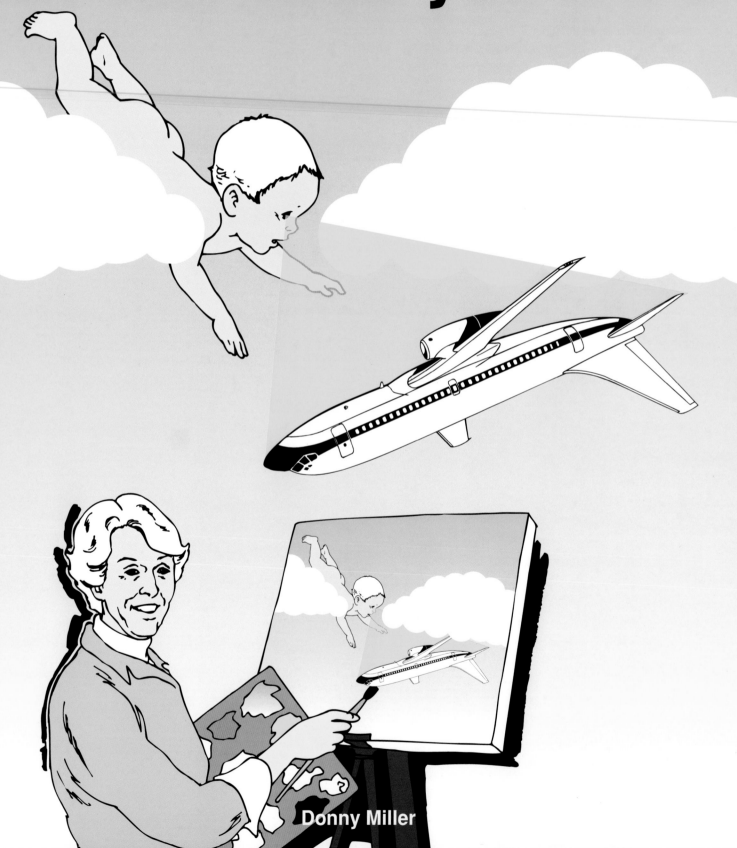

Donny Miller

The Terrible Twos

After a little soul searching,
I chewed my father's face off.

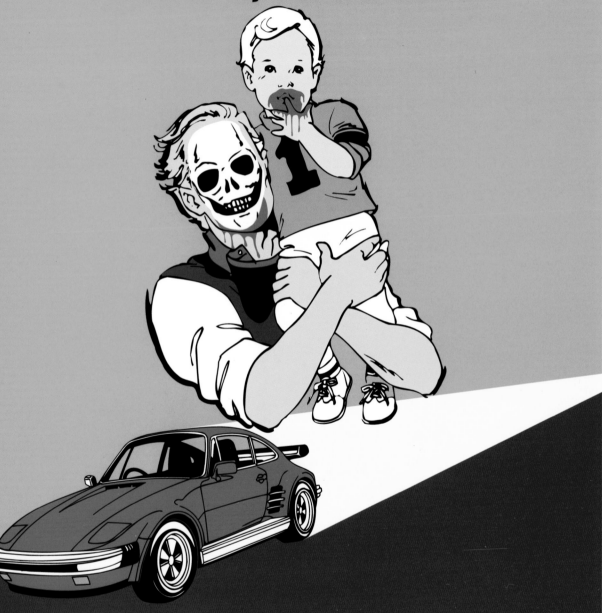

Later that night, I drove his Porsche to a motel and ordered fried chicken to celebrate my independence.

Donny Miller

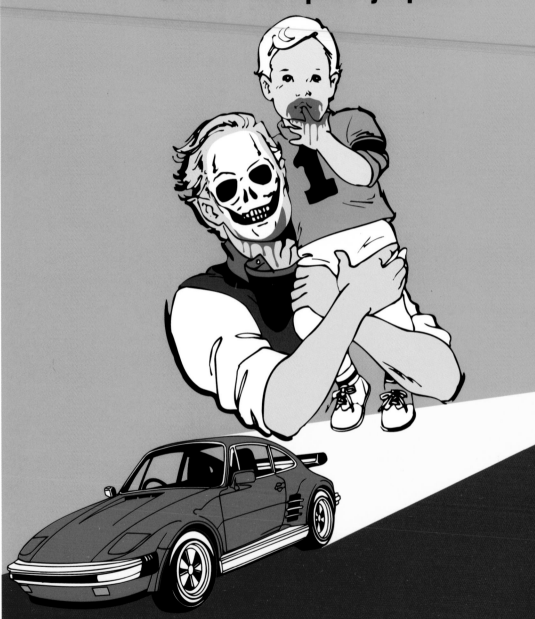

Le Du Enfanté Terribles

Jé natame le oui, pierenes bon avion. Le quell jaques.

**Mase, Jé fatigue un le trobe.
Jé suite lanier ce si bon.
Le troi un l'resistance.**

Donny Miller

You're old enough to make up your own mind about what it is you think you see.

Donny Miller

What stereotype are you?

Donny Miller

Donny Miller

Where did your life go wrong? Was it that one bit of pain you just couldn't take any more of?

Donny Miller

I'm practicing being a better person on you.

Donny Miller

I'm the only person on earth who has ever experienced pain.

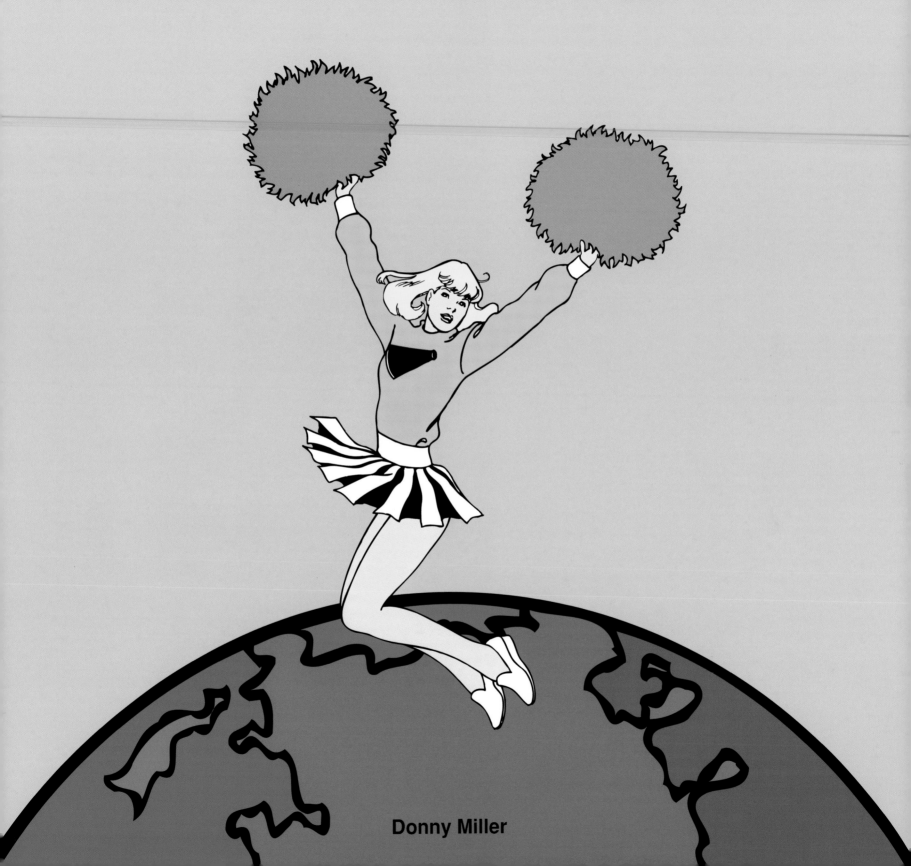

Donny Miller

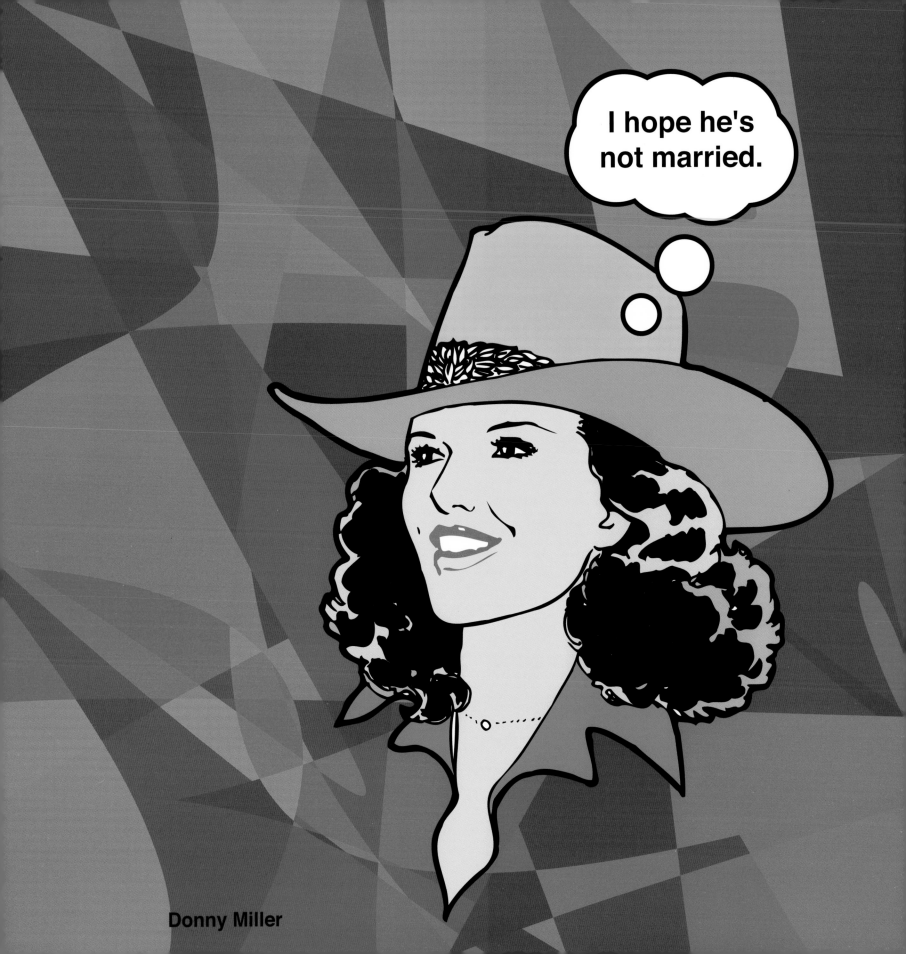

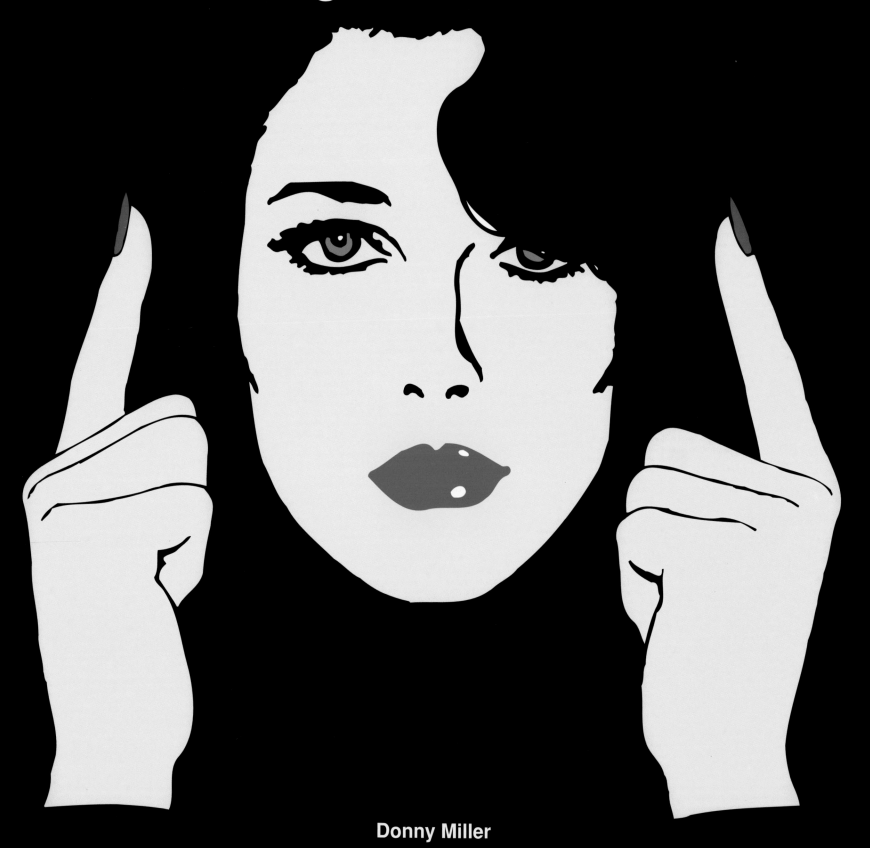

Expectations are disappointments in disguise.

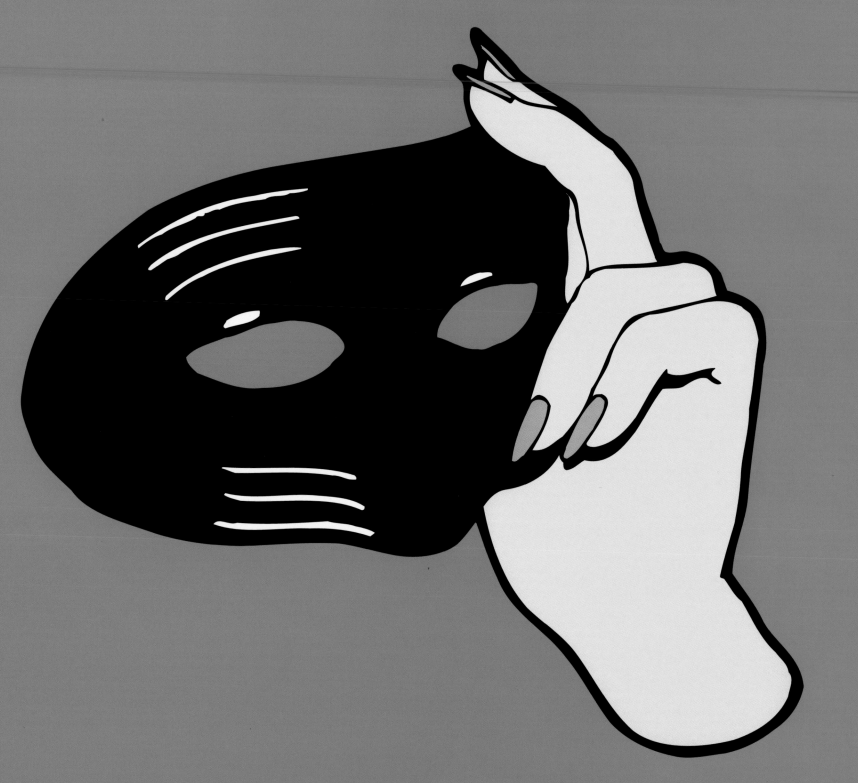

Donny Miller

Most tragedies become romantic memories.

Donny Miller

Do you think I should finish becoming a human?

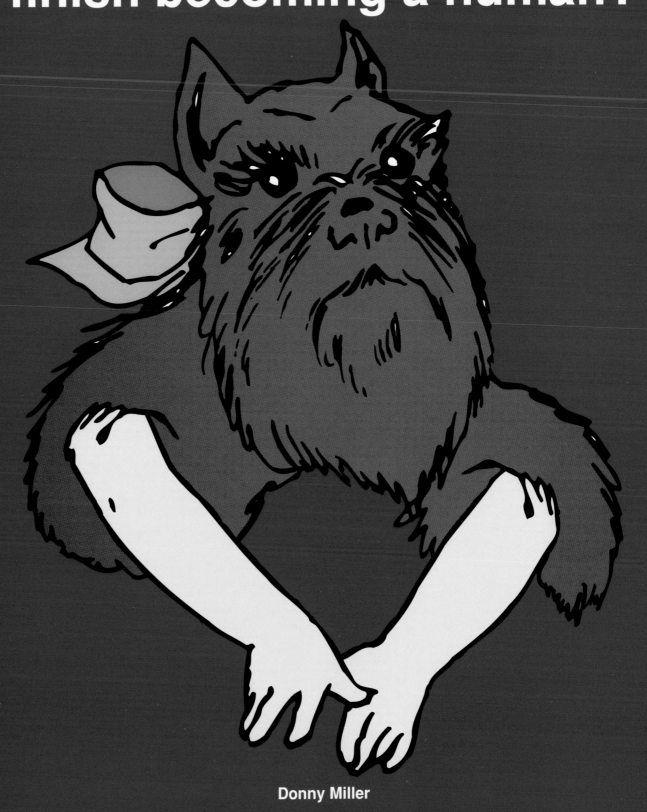

Donny Miller

I would love to be killed
by a beautiful woman.

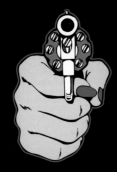 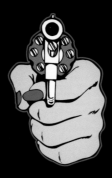

Donny Miller

Free will is man's only flaw.

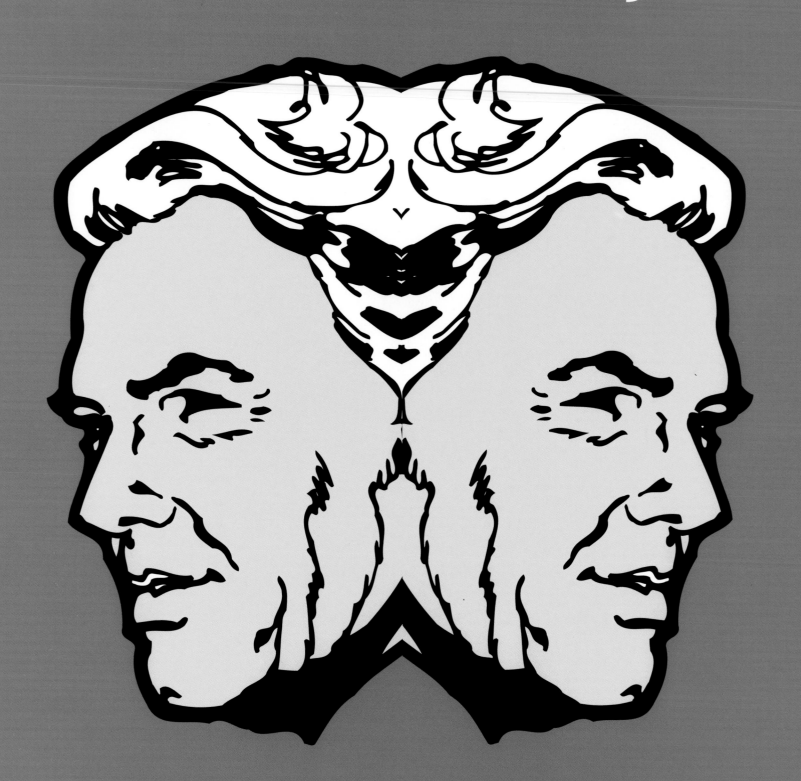

Donny Miller

Money fixes everything.
Just rub it on any problem you have in your life.

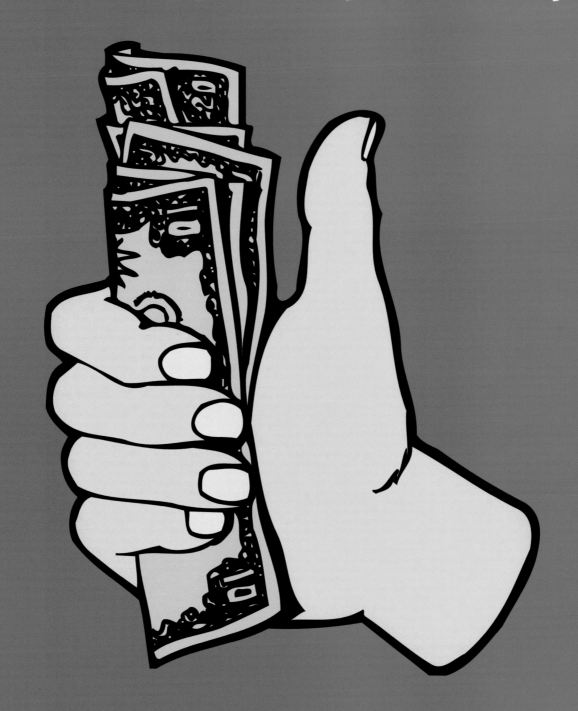

Donny Miller

I used to think women who looked past my flaws were really cool women with brains. Now I just think they're desperate.

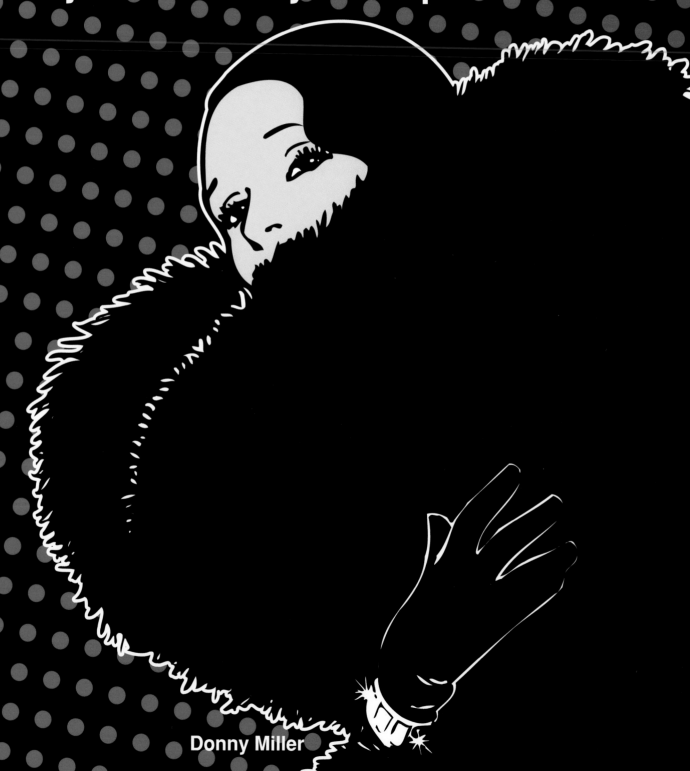

Donny Miller

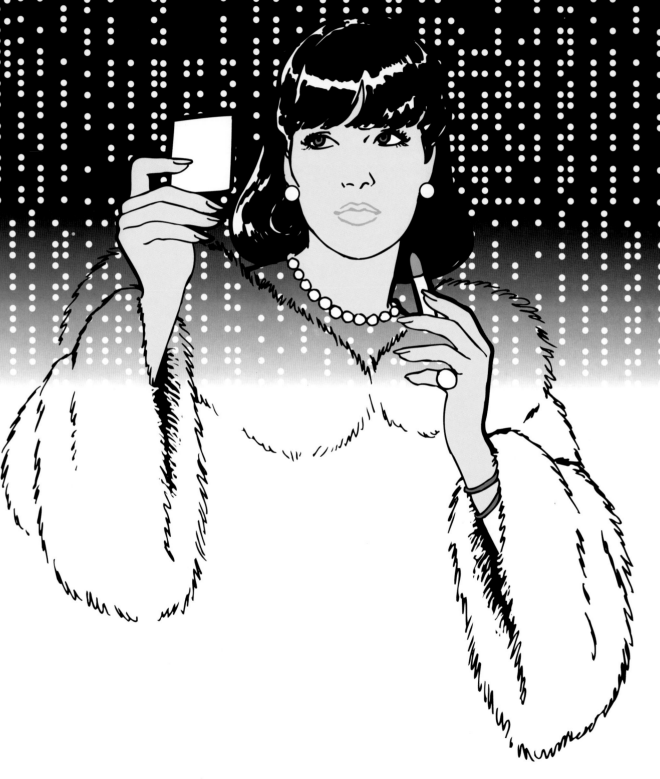

Donny Miller

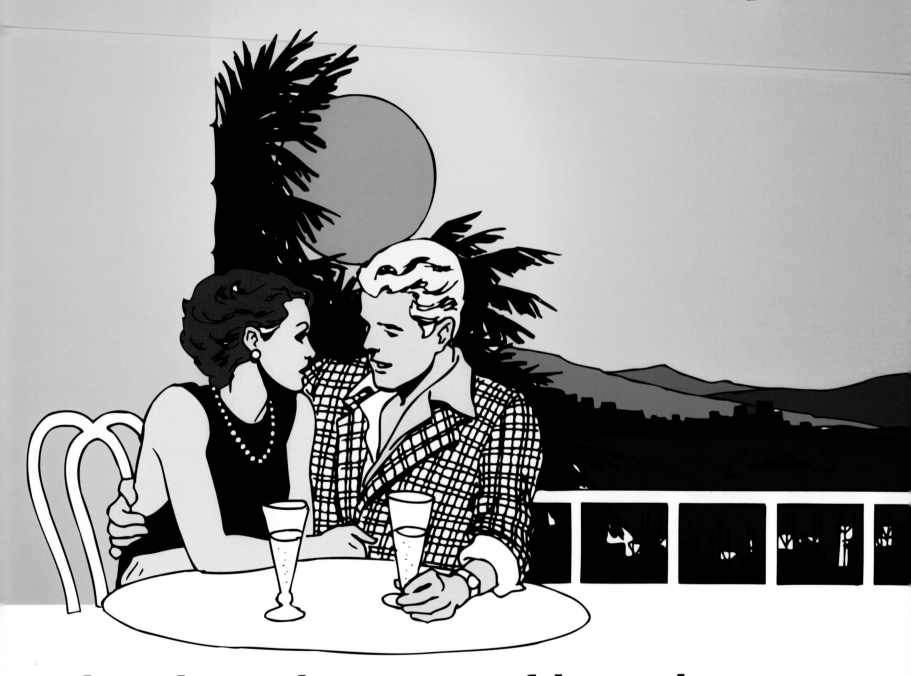

It's sad to think we might just be wasting each other's time and that this might be just another pointless relationship.

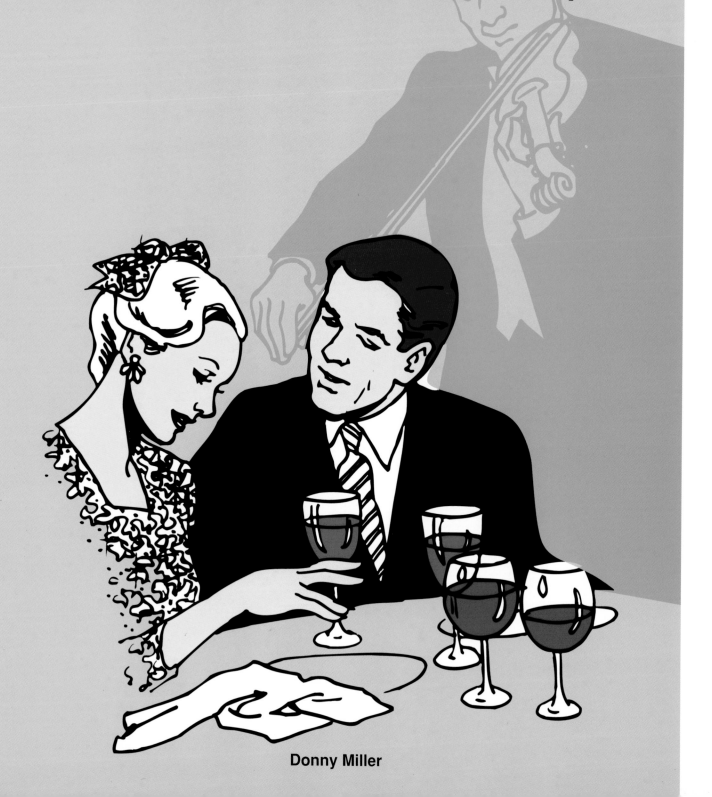

Donny Miller

How ever will I repay you for your priceless compliments?

Donny Miller

I was so horny,

I masturbated thinking of my own girlfriend.

Donny Miller

Masturbation is a touchy subject.

Donny Miller

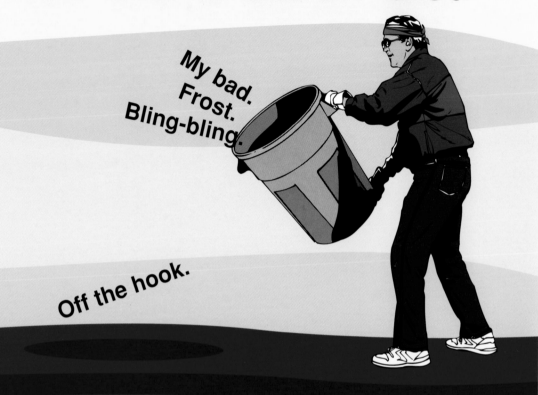

. . . and all the fair girls in the land wanted to touch the giant beard in the sky.

Donny Miller

I will always love you.
No matter what my horoscope says.

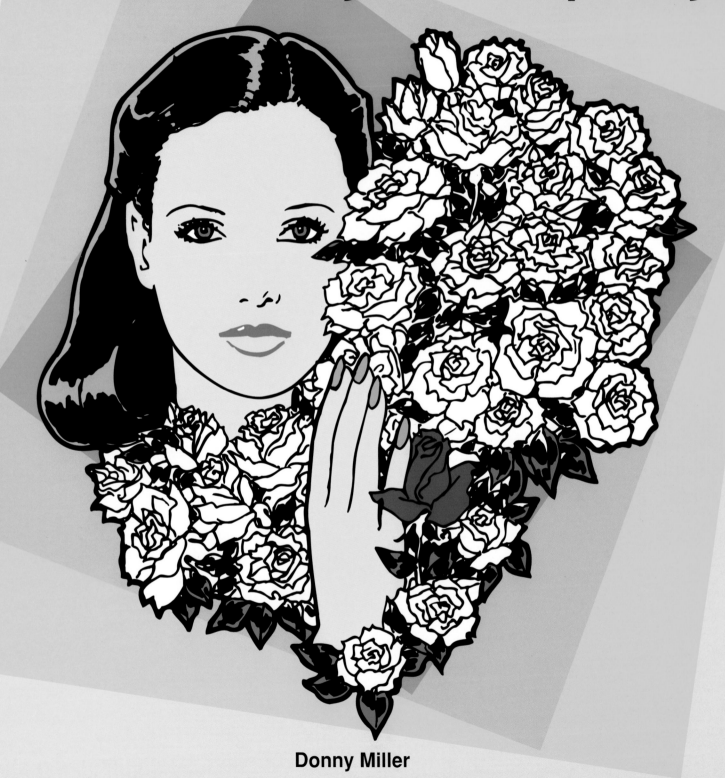

Donny Miller

I will always be chasing the way I want to look.

Donny Miller

That picture you took of me ruined my self-esteem forever.

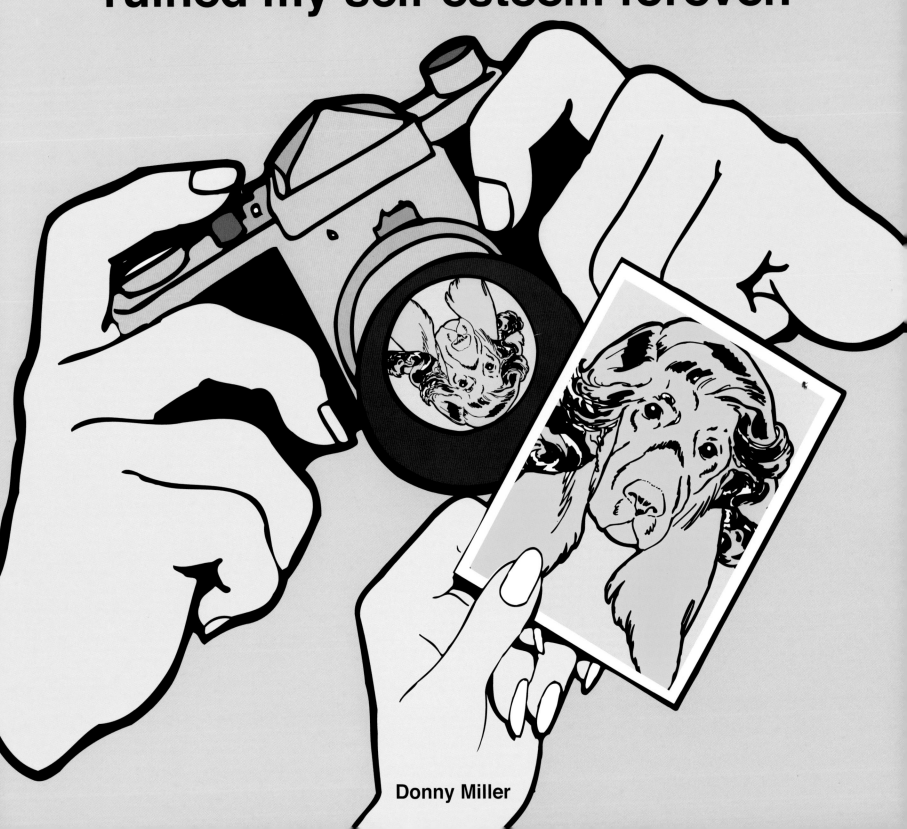

Donny Miller

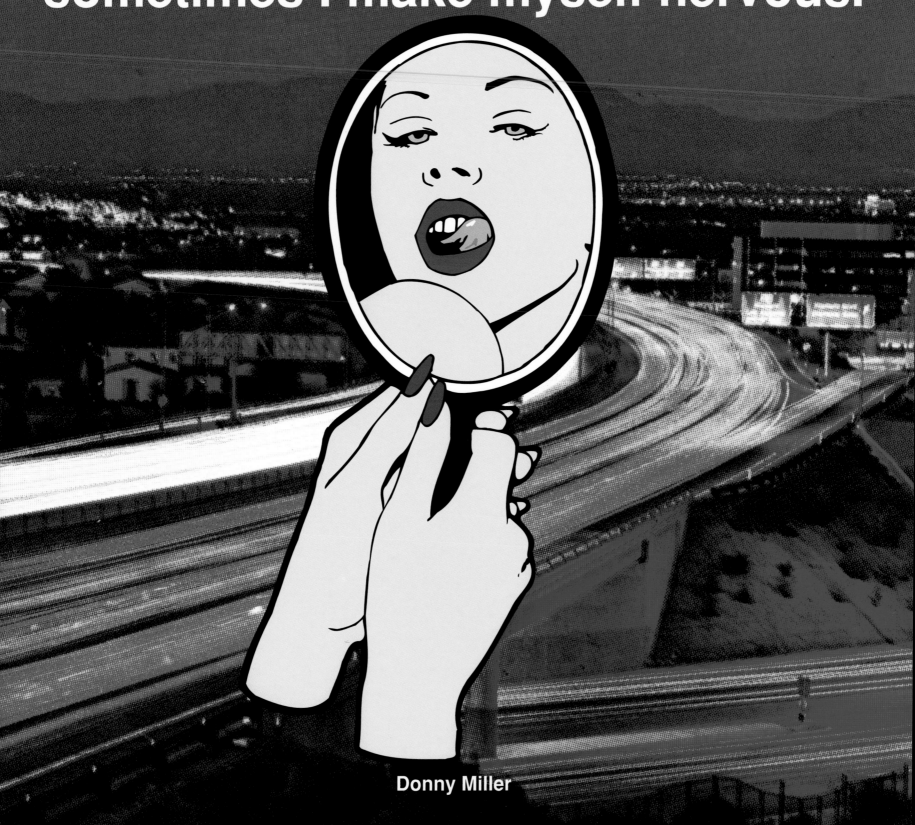

I'm so gorgeous,
sometimes I make myself nervous.

Donny Miller

Beauty is a prison sentence.

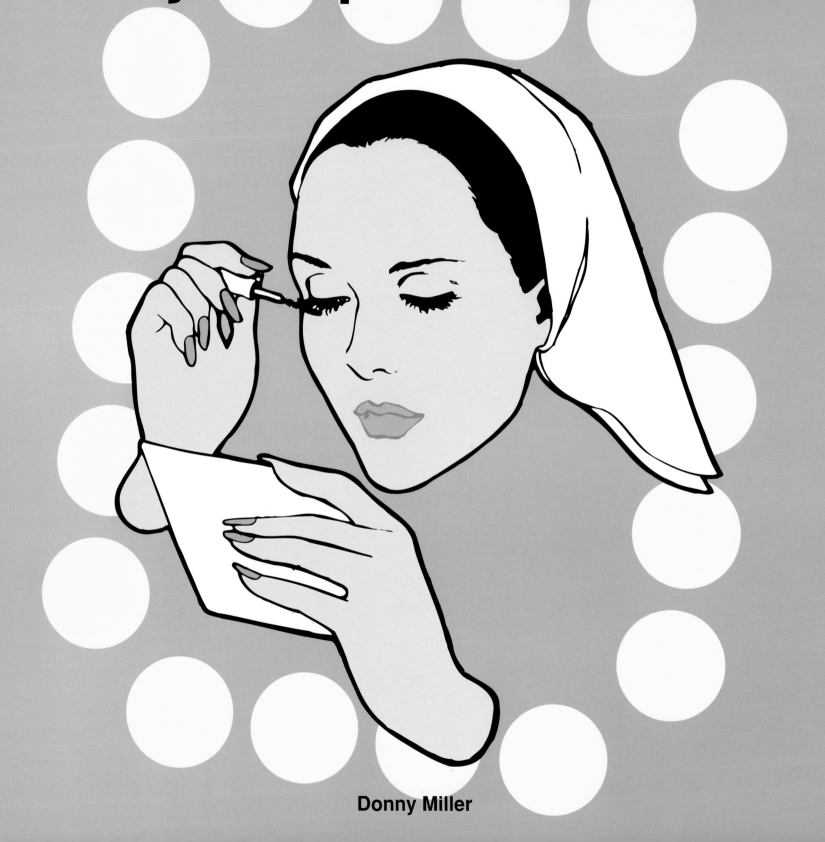

Donny Miller

I'm getting so good at dealing with all my insecurites.

Donny Miller

You are beautiful in every single way, except maybe one or two.

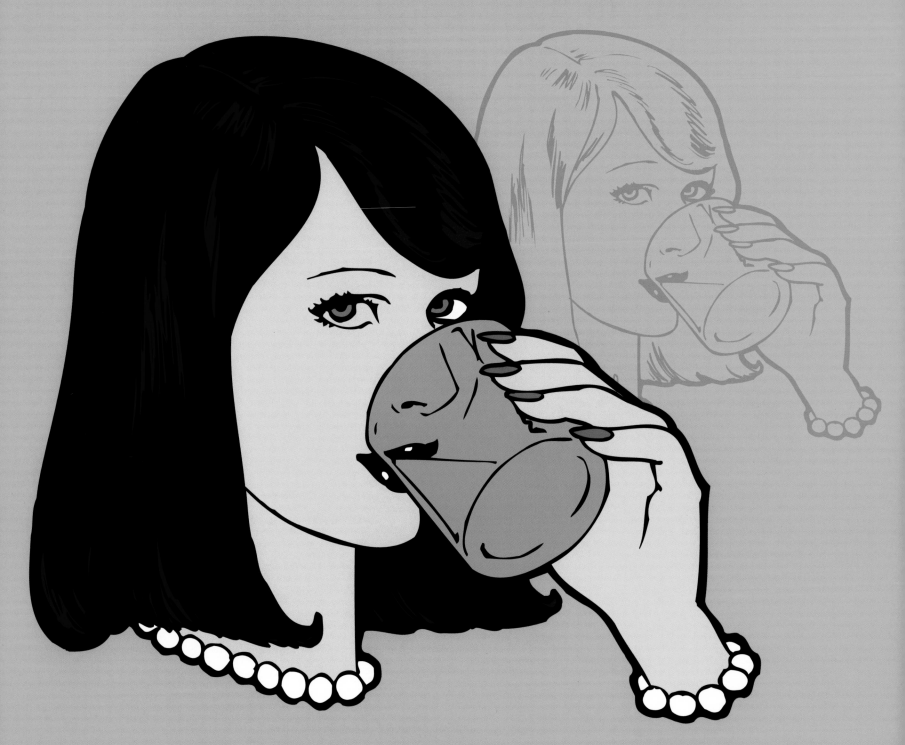

Donny Miller

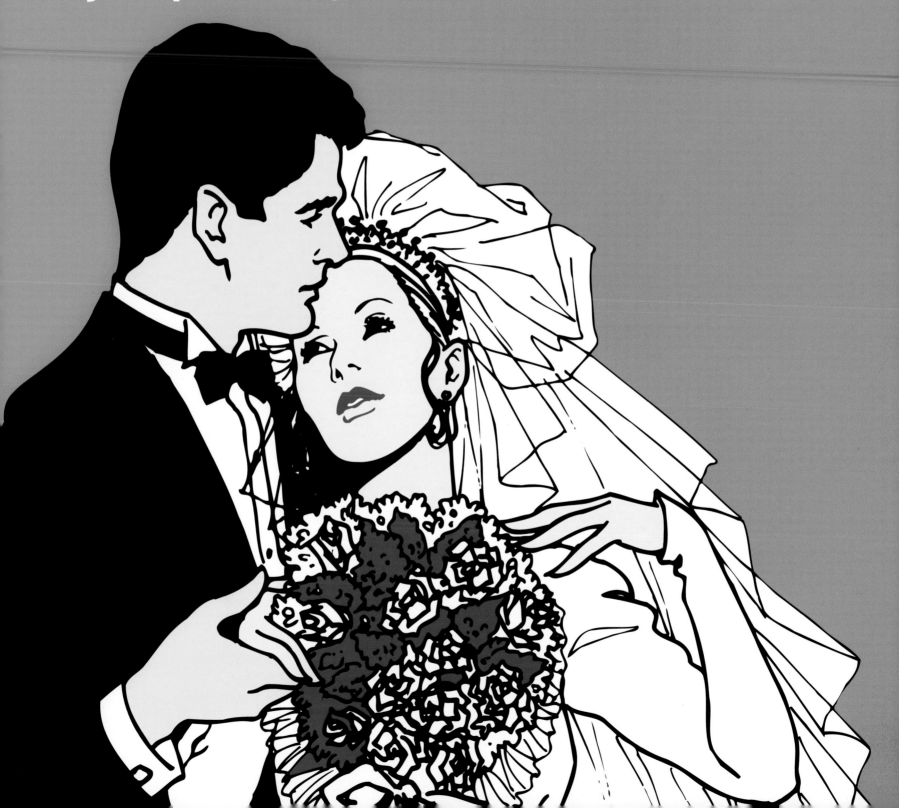

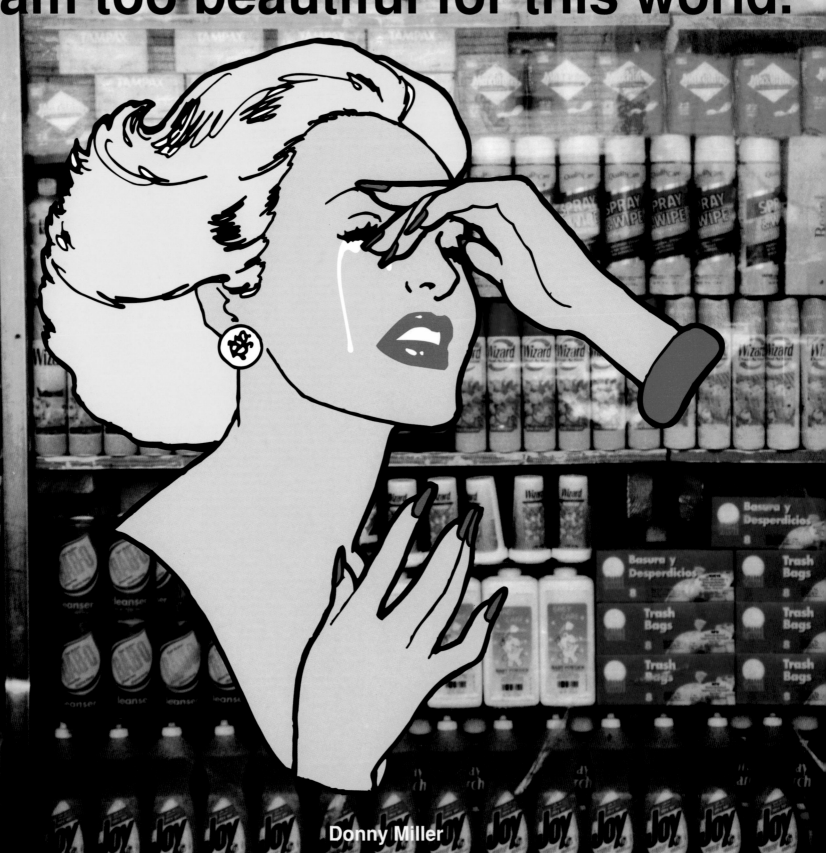

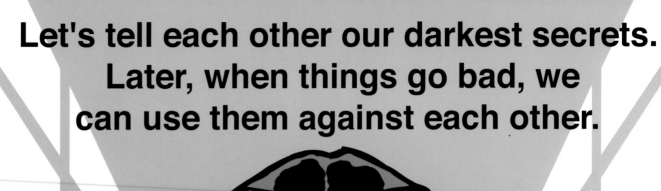

Let's tell each other our darkest secrets. Later, when things go bad, we can use them against each other.

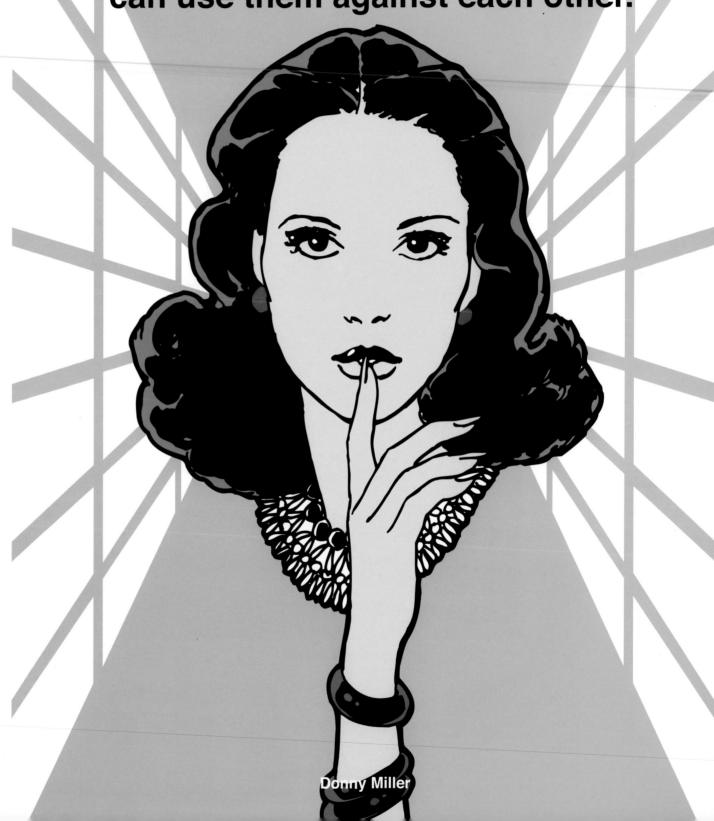

Donny Miller

The world would be unbearable without euphemisms.

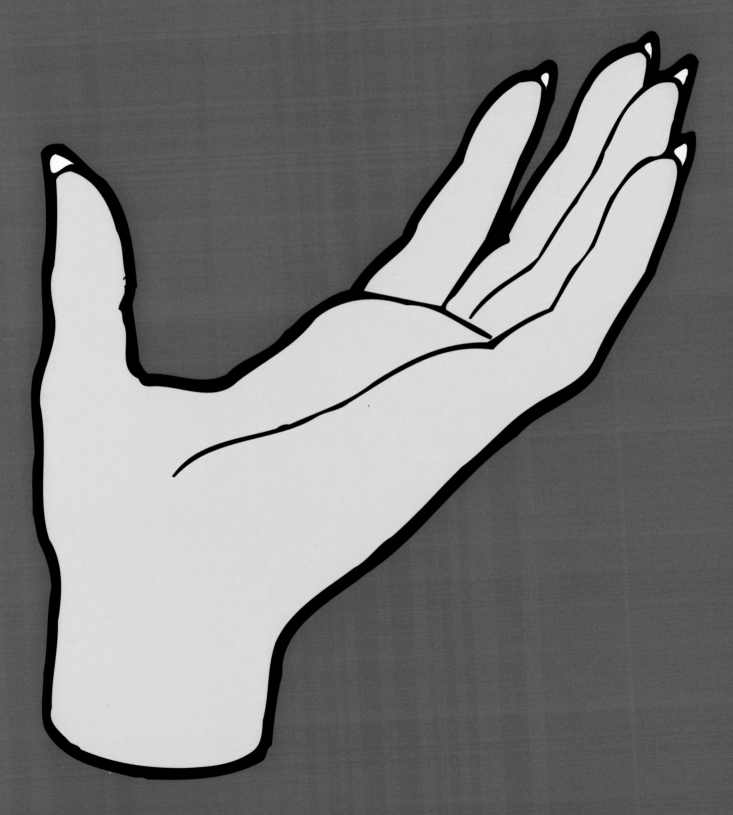

Donny Miller

We don't communicate anymore. We just talk.

Donny Miller

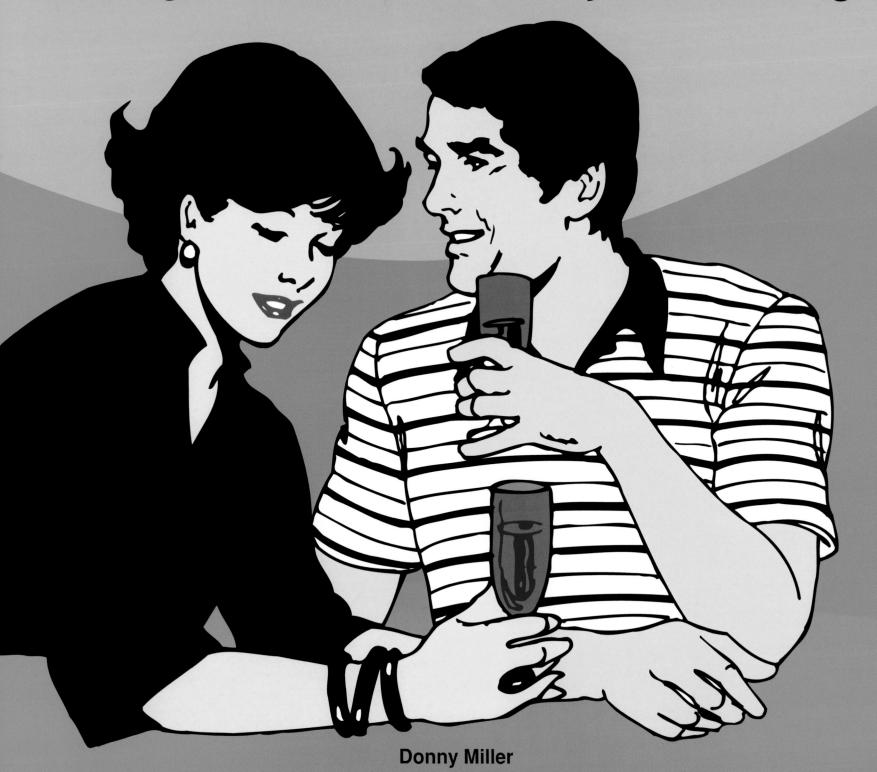

One day we'll both be gone and we'll never see each other again.

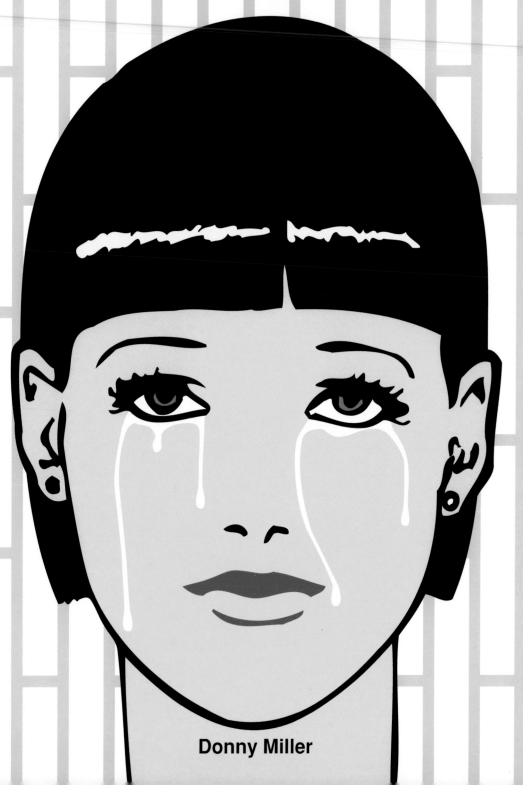

Donny Miller

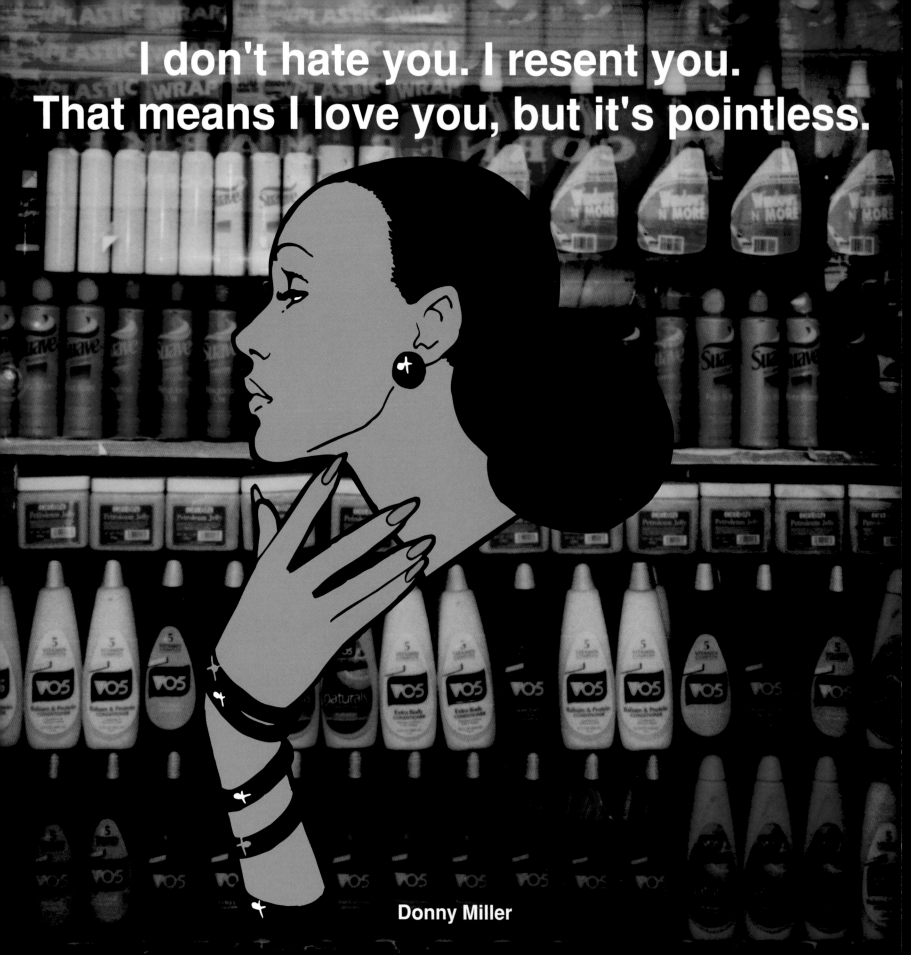

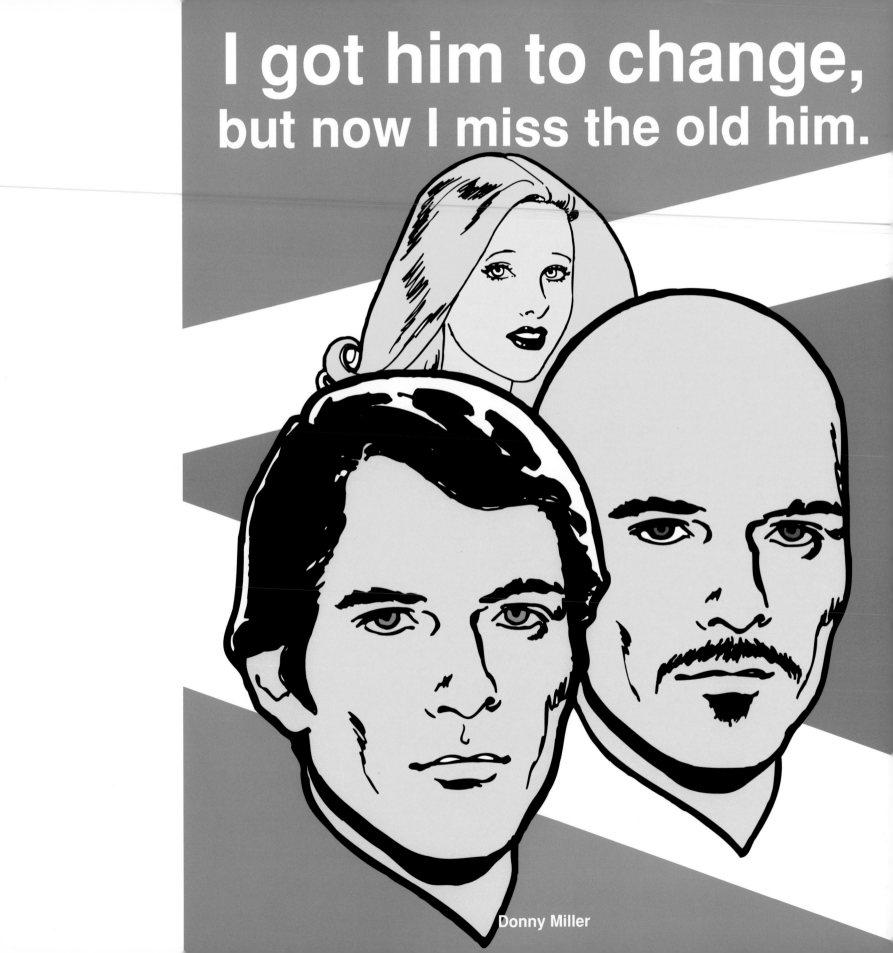

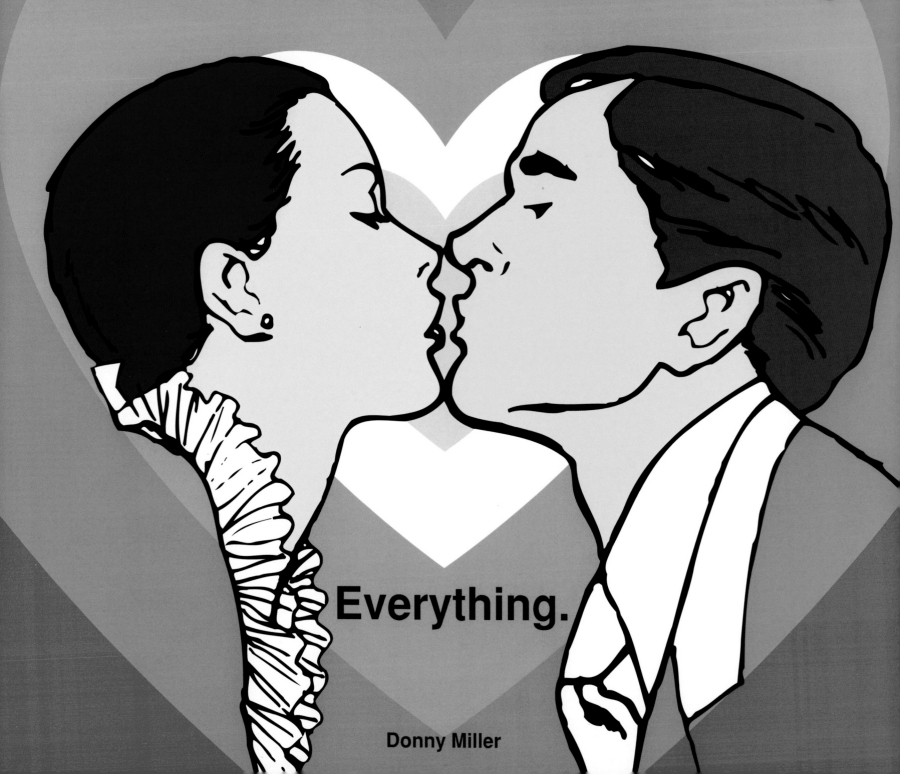

Suddenly, I realized I was wearing this silly little hat just to please him.

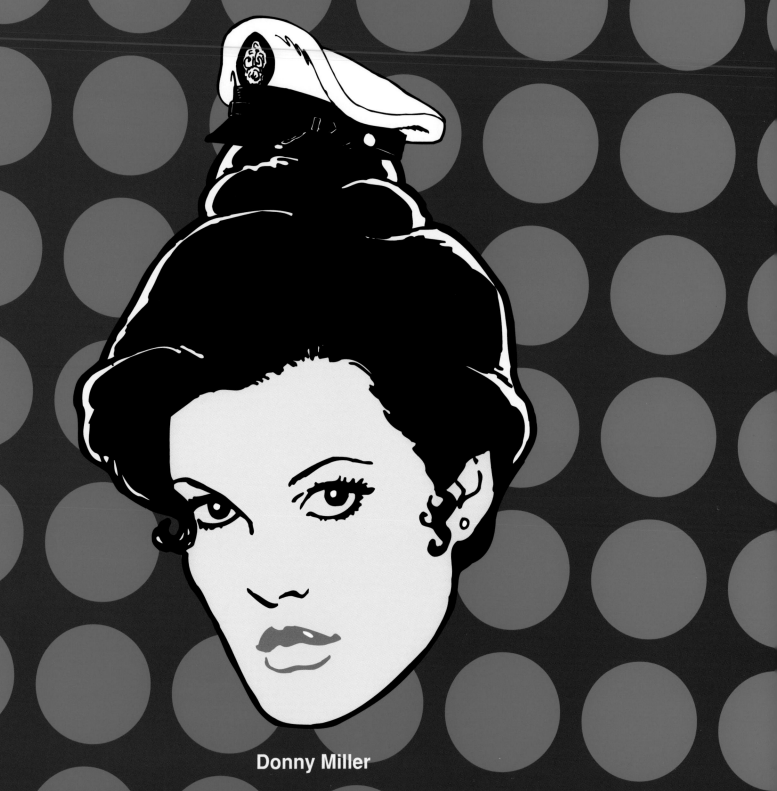

Donny Miller

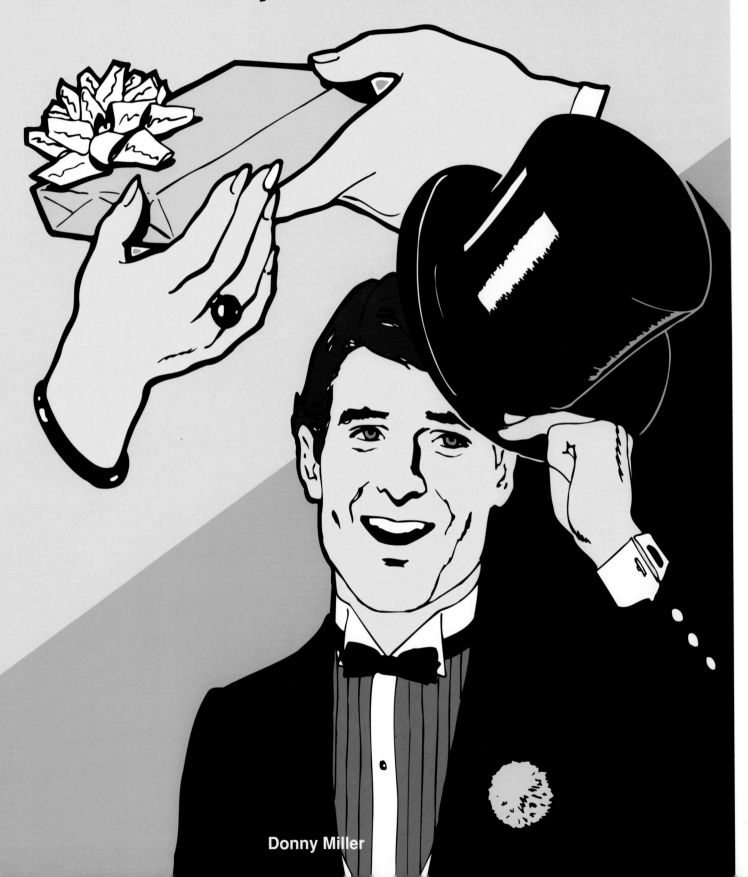

I'd like you a lot more if you liked me a lot less.

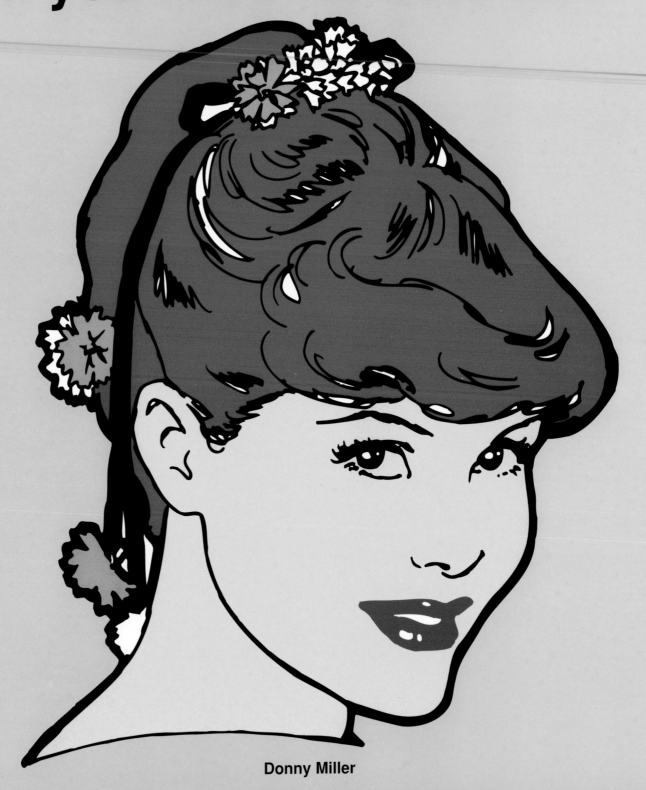

Donny Miller

Some explanations are pointless.

Donny Miller

We're at that point in our relationship where I'll have sex with anyone but you.

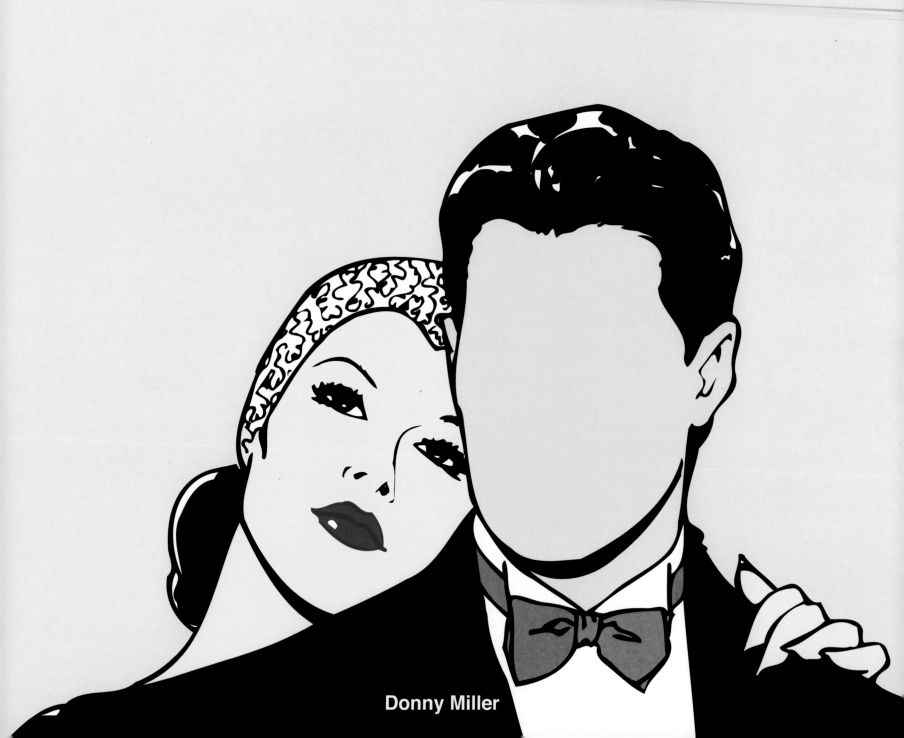

Donny Miller

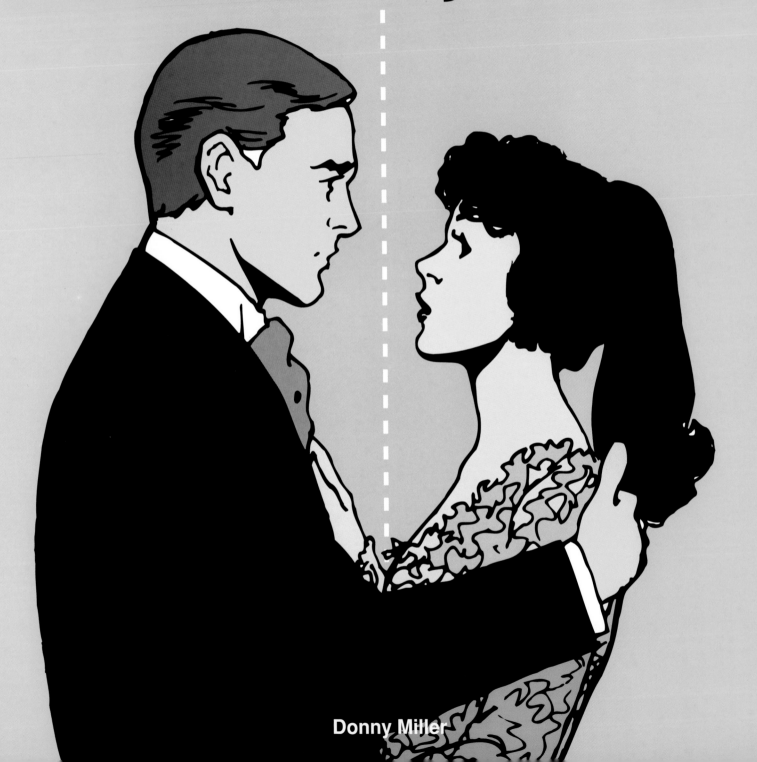

He got so cool, he became an unbearable asshole everyone hated.

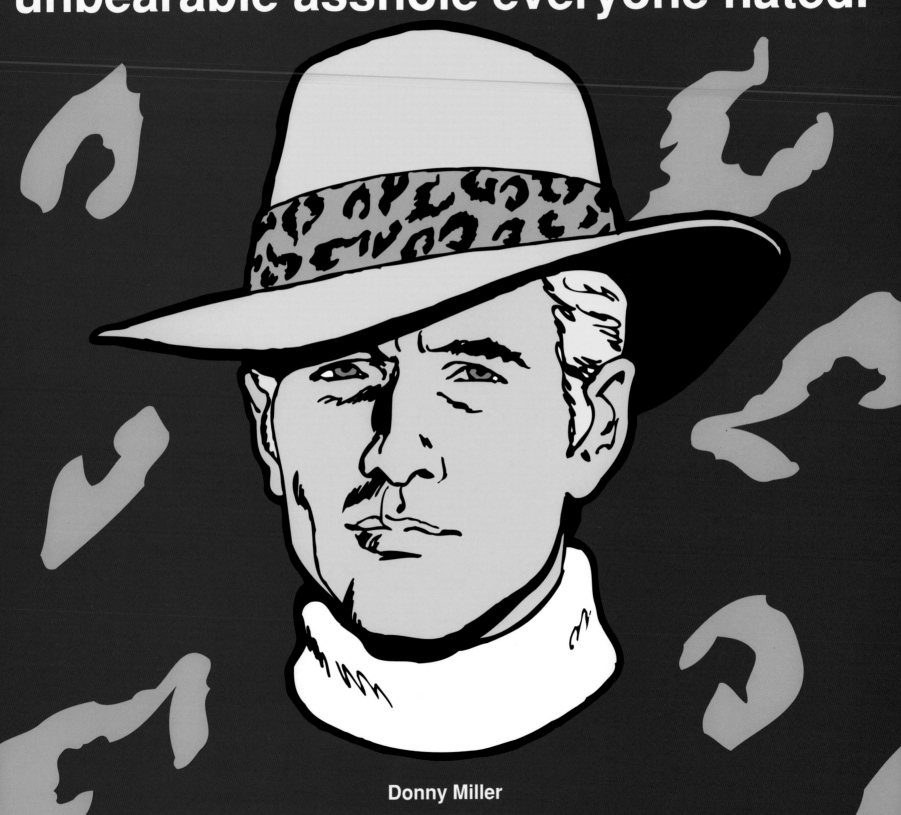

Donny Miller

You have to fool yourself before you can fool everyone else.

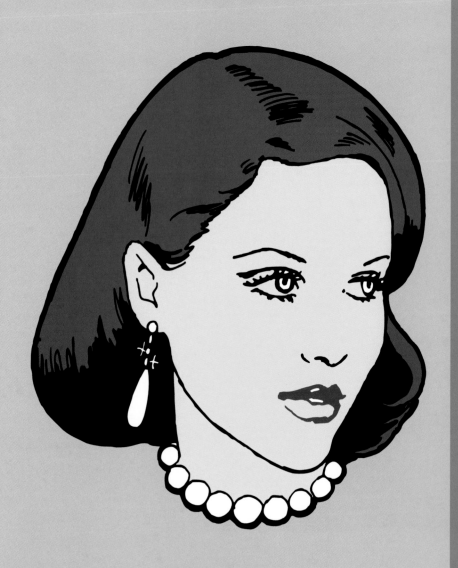

Donny Miller

Some problems don't have solutions.

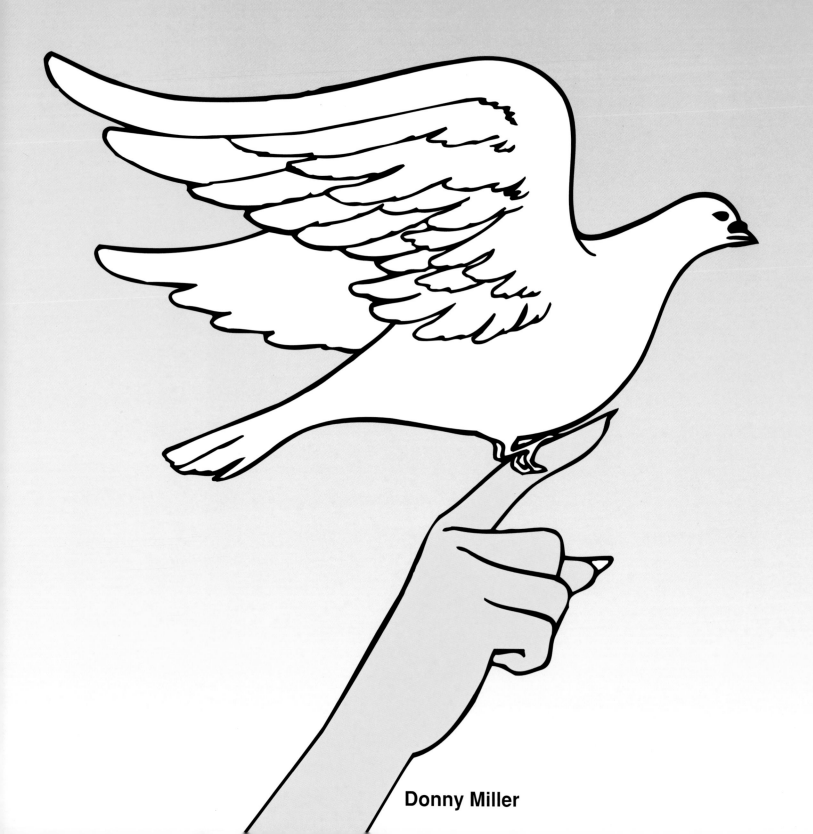

Donny Miller

I had a vision of love and you weren't in it.

Donny Miller

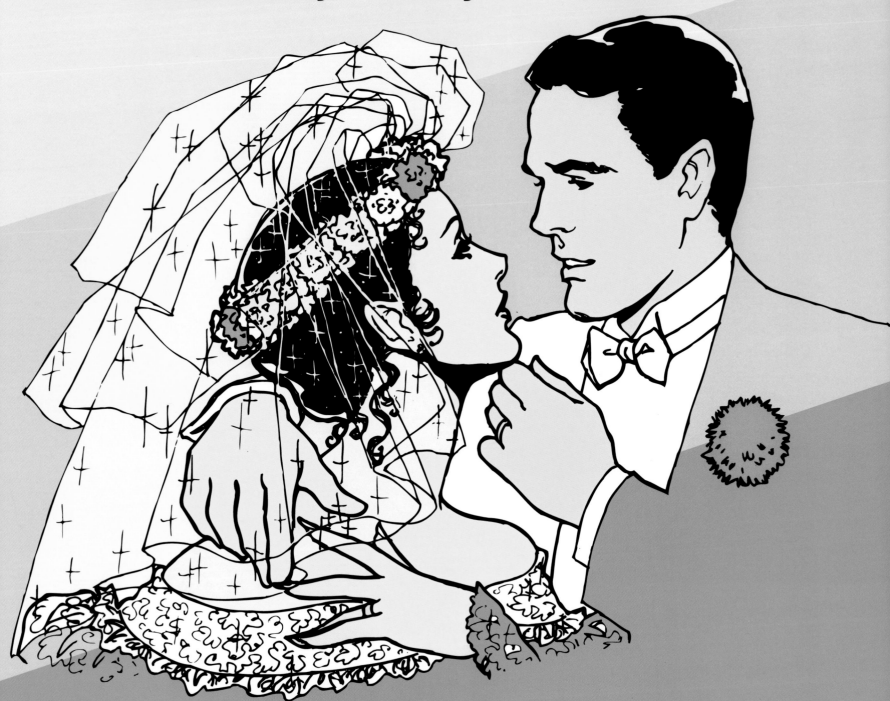

Girl, you're every woman in the world to me.
Even the black and Jewish ones.
That's why I hate you sometimes.

Donny Miller

You killed the part of me that cares.

Donny Miller

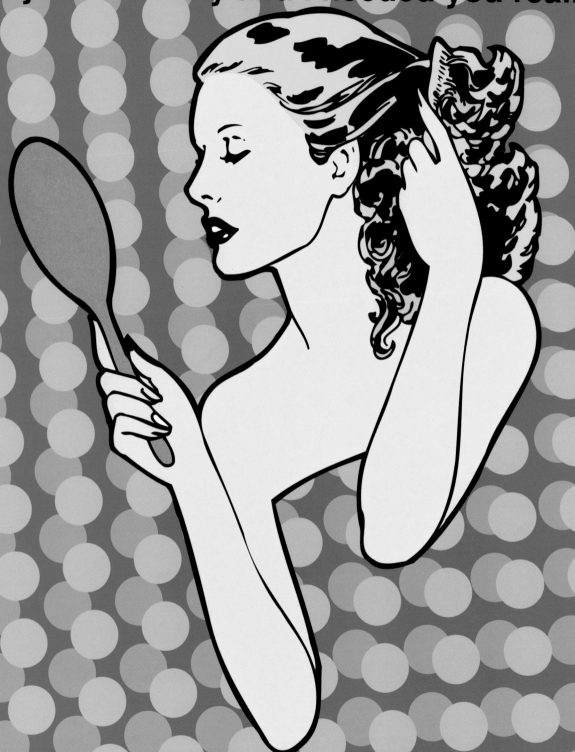

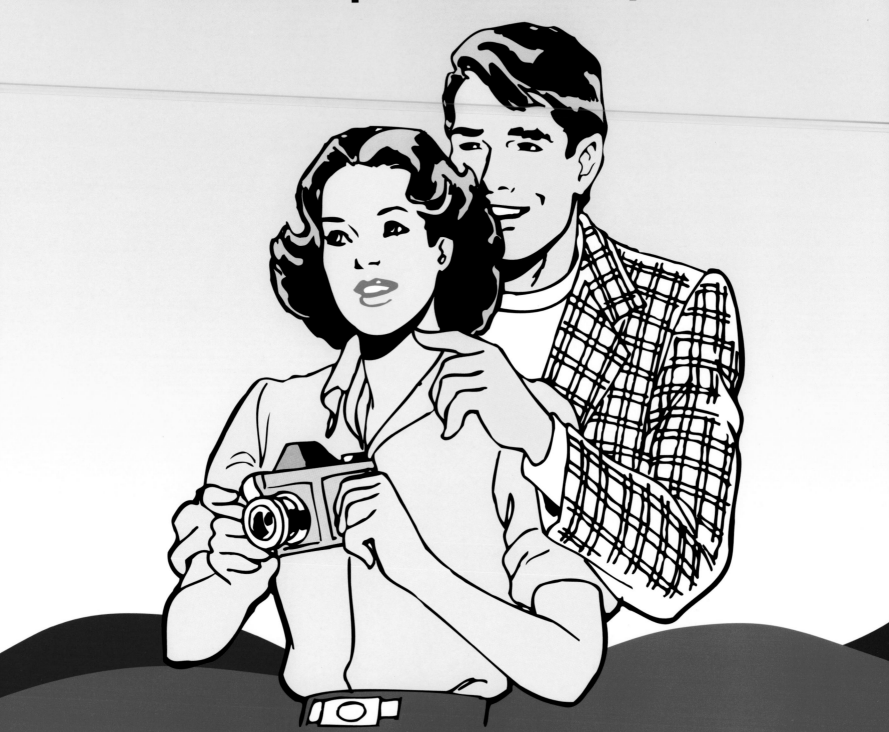

The negative things people say are much more memorable.

Donny Miller

My life is holding the universe together.

Donny Miller

Now that you're my problem, who will I tell my problems to?

Donny Miller

I don't care anymore.

Donny Miller

It only hurts if you care.

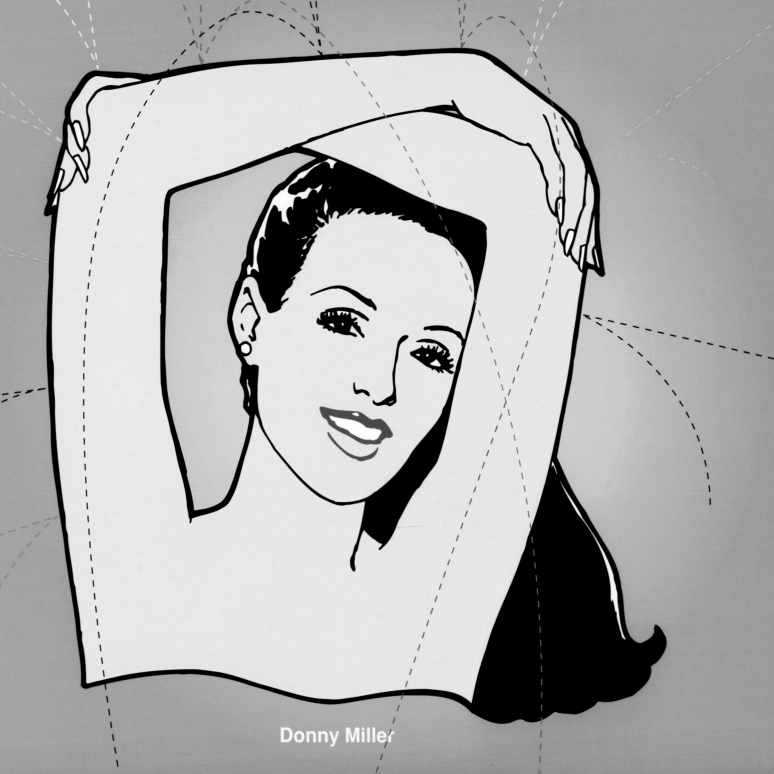

Donny Miller

I play games when
I don't know what I want.

Donny Miller

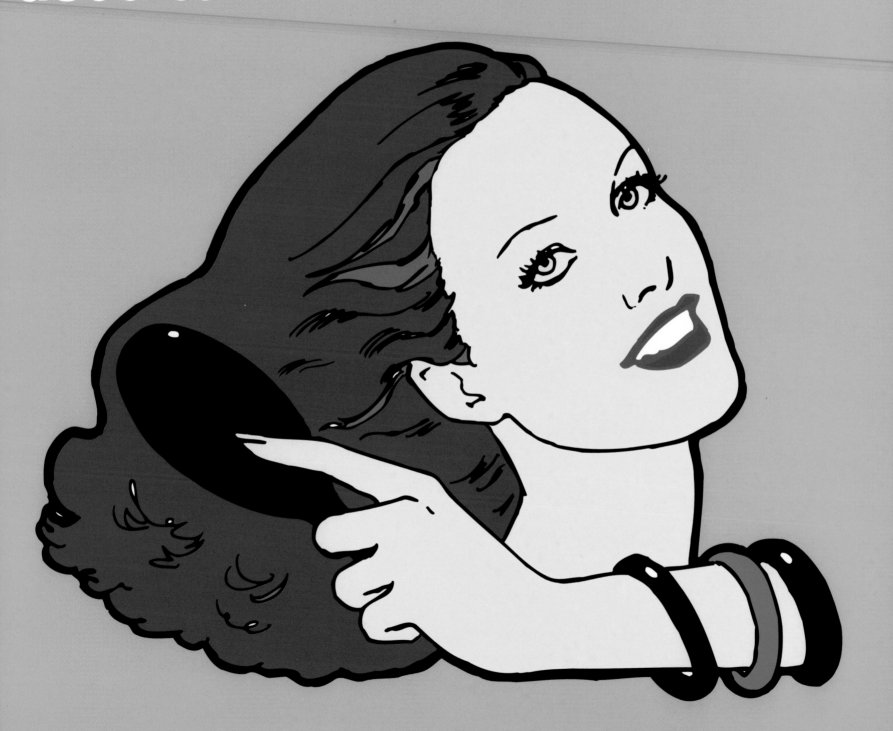

I can't believe your opinion used to matter so much to me.

Donny Miller

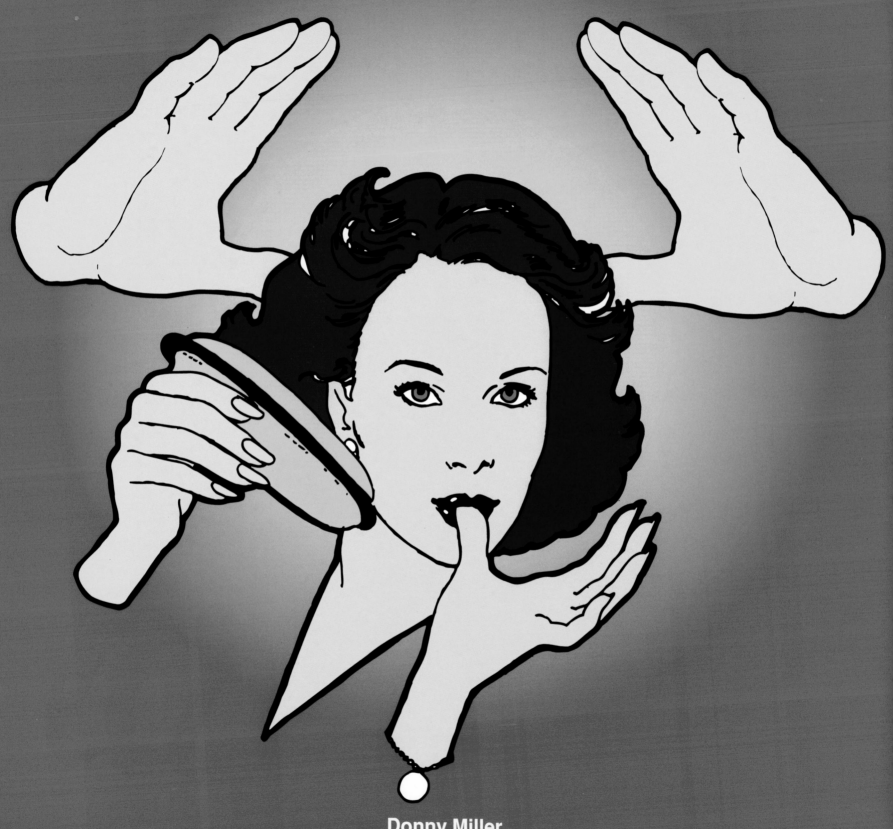

Everyone is forming an opinion about you.

Donny Miller

Get high on hope!
It's free and you can make it as unrealistic as you like!

Donny Miller

I don't carry a torch for him anymore.
Just this match.

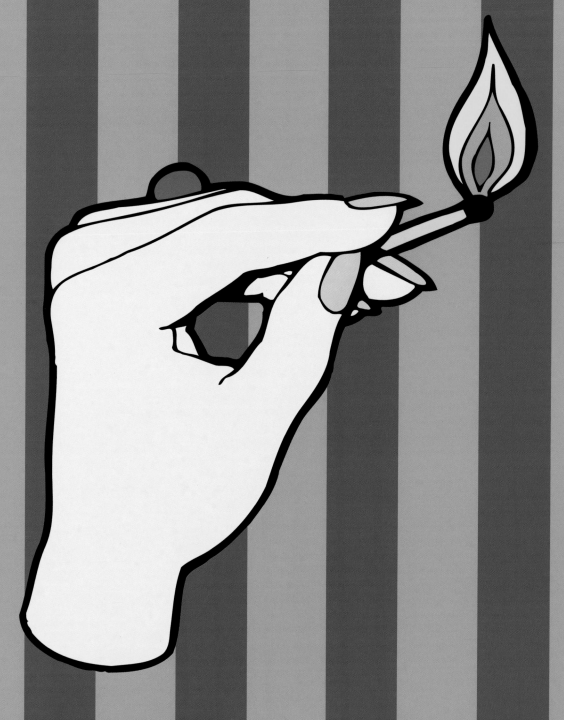

Donny Miller

Let me give you some advice based on the regrets I've had.

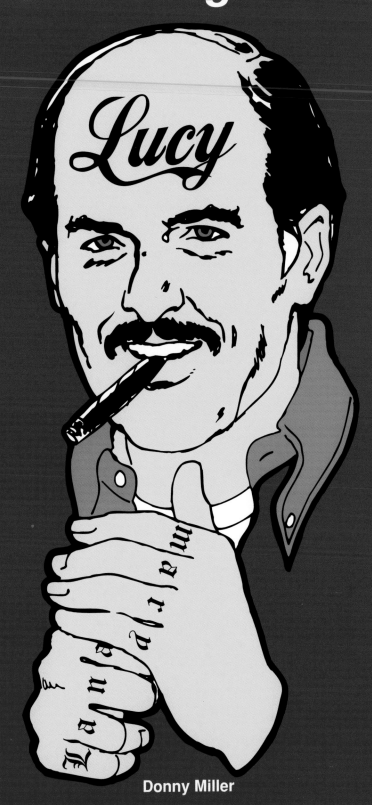

Donny Miller

Getting over her was easy, because she was ugly.

Donny Miller

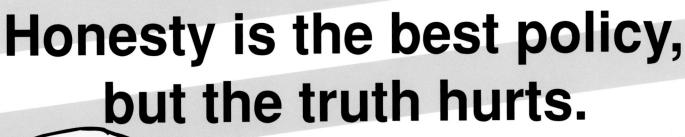

Honesty is the best policy, but the truth hurts.

Makes lying seem not so bad.

Donny Miller

I'm only ugly on the inside.

Donny Miller

I'll walk all over you, if you let me.

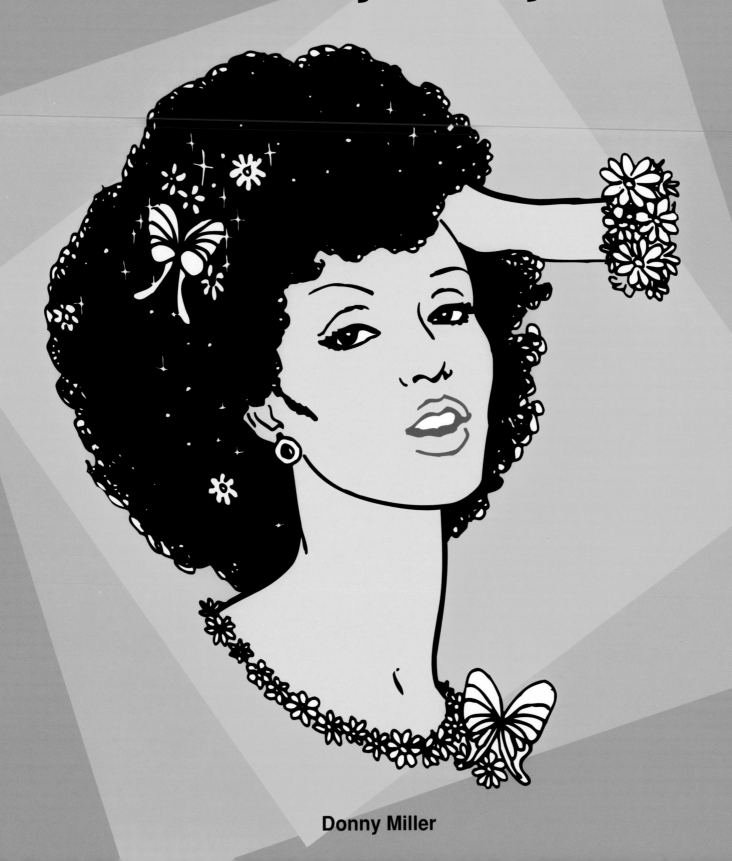

Donny Miller

Guilt is a popular tool.

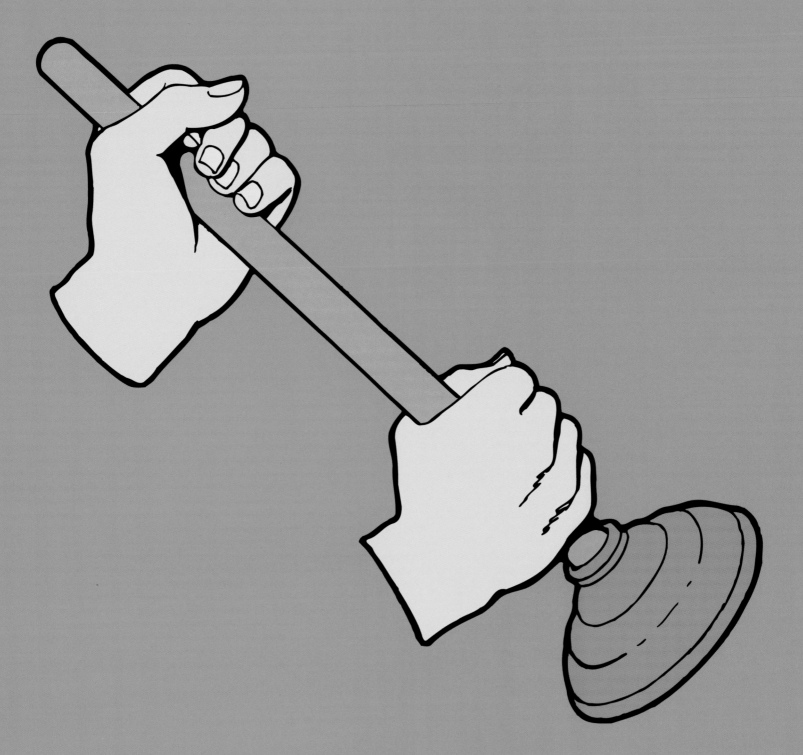

Donny Miller

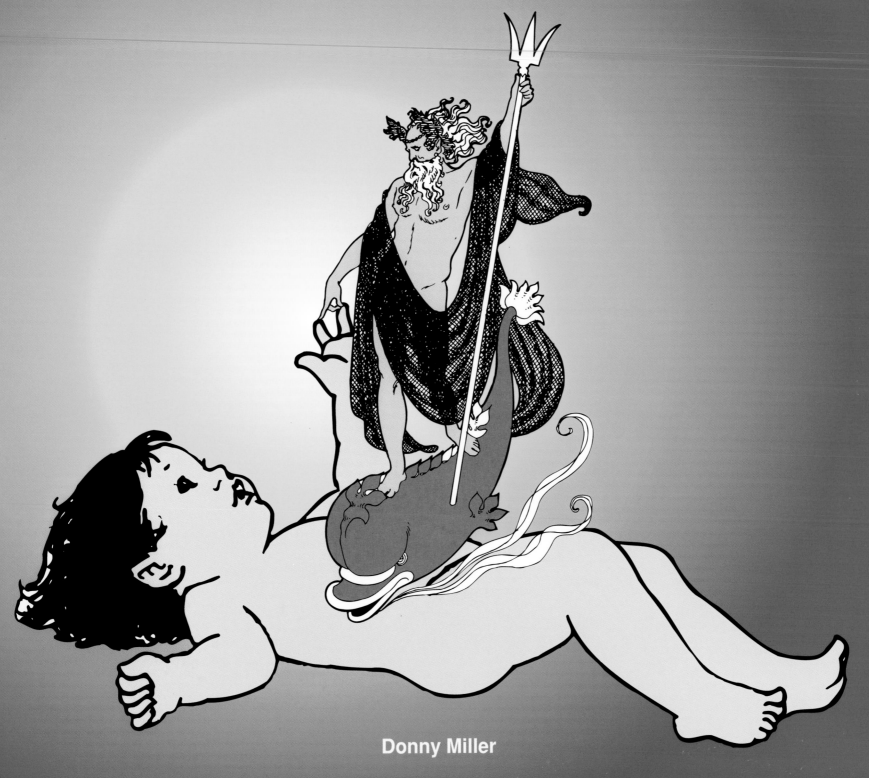

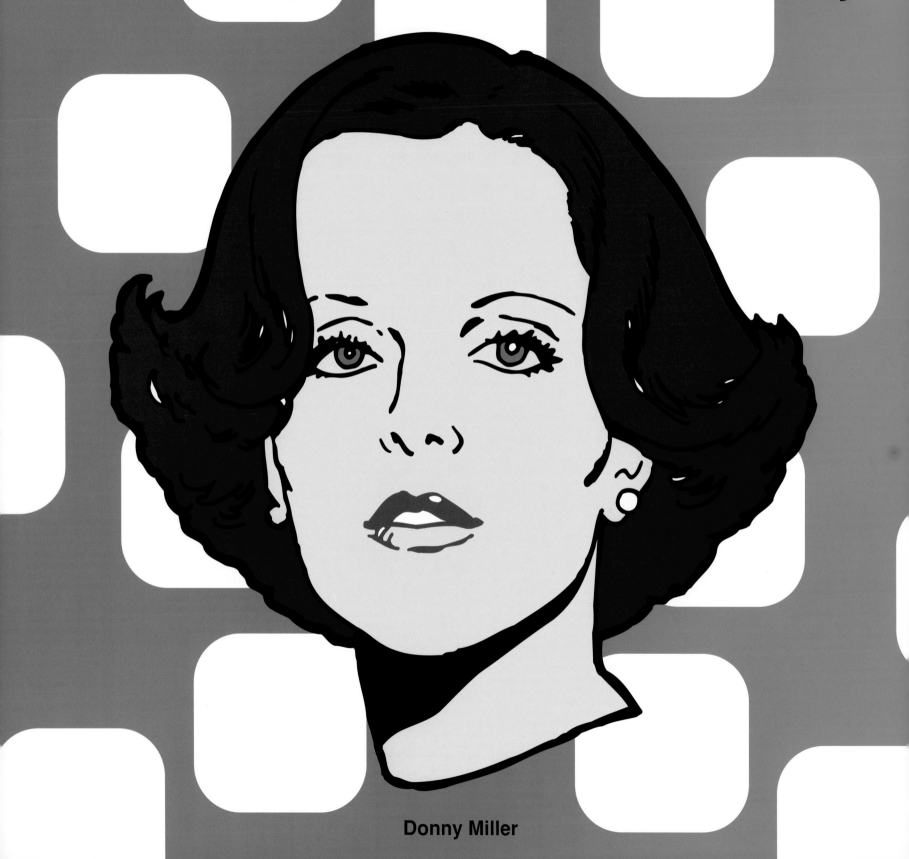

I'm only serious when I'm not taken seriously.

Donny Miller

I forgot the idea for this piece.

It was brilliant.
The best I ever thought of.

Donny Miller

Cut this out and shove it up your ass.

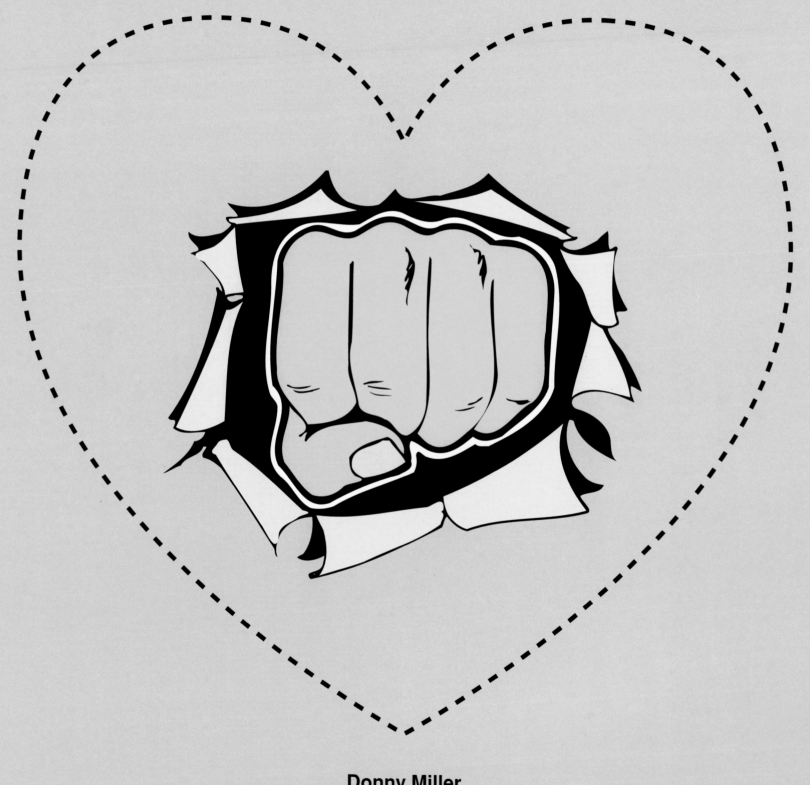

Donny Miller

Every cynic is dying to be loved.*

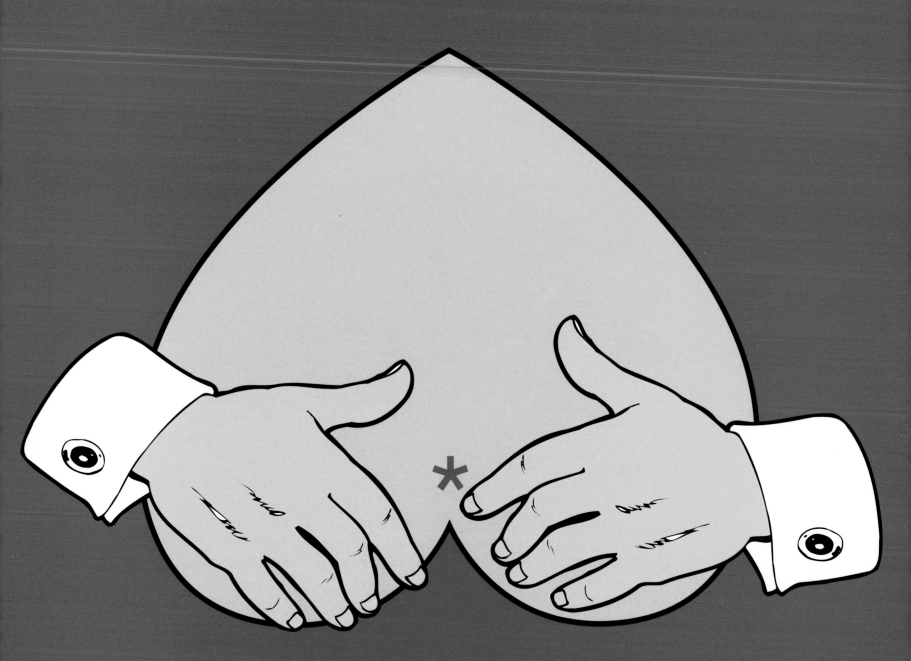

Donny Miller

One day the bottle where I keep all my feelings inside broke.

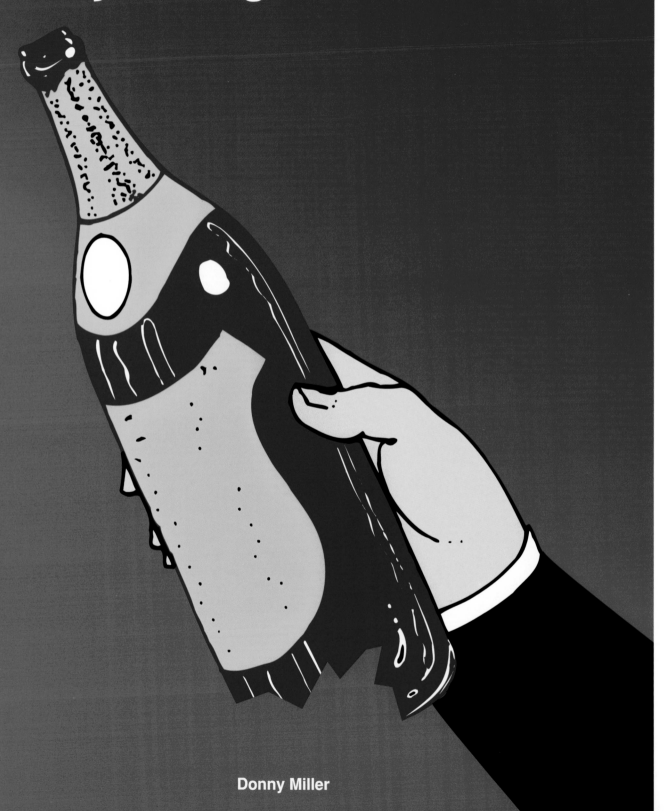

Donny Miller

Enjoy ignorance.

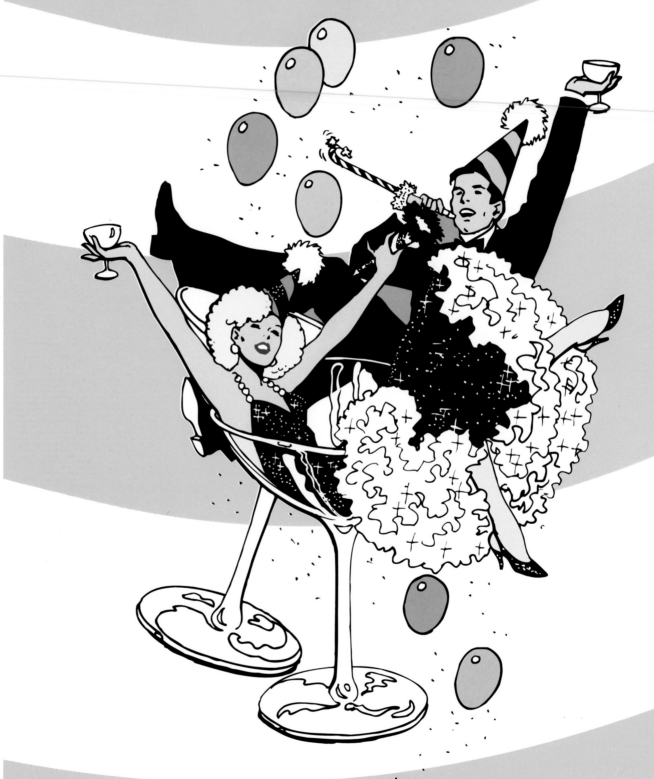

Donny Miller

The only thing you can change is your mind.

Donny Miller

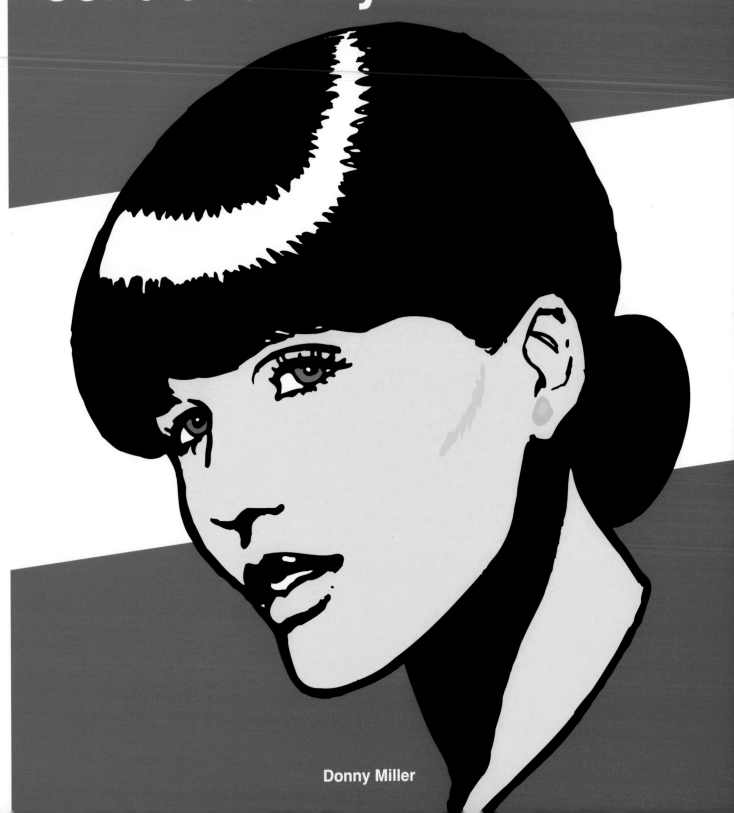

The only thing you have control of is your reaction.

Donny Miller

Everyone's holding my happiness hostage.

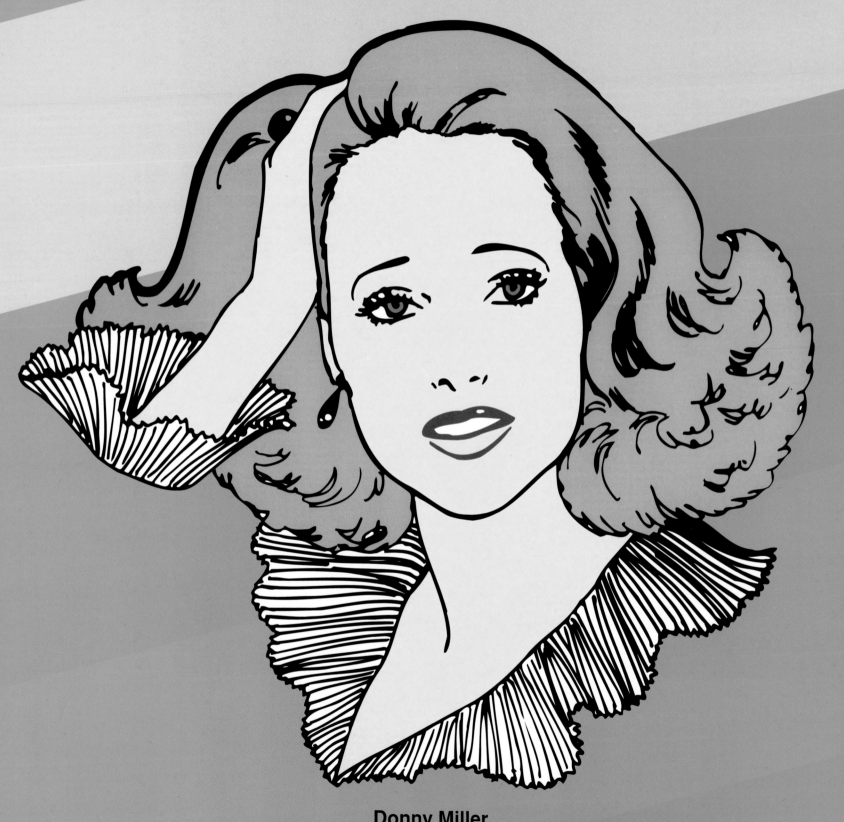

Donny Miller

When is the life I want going to begin?

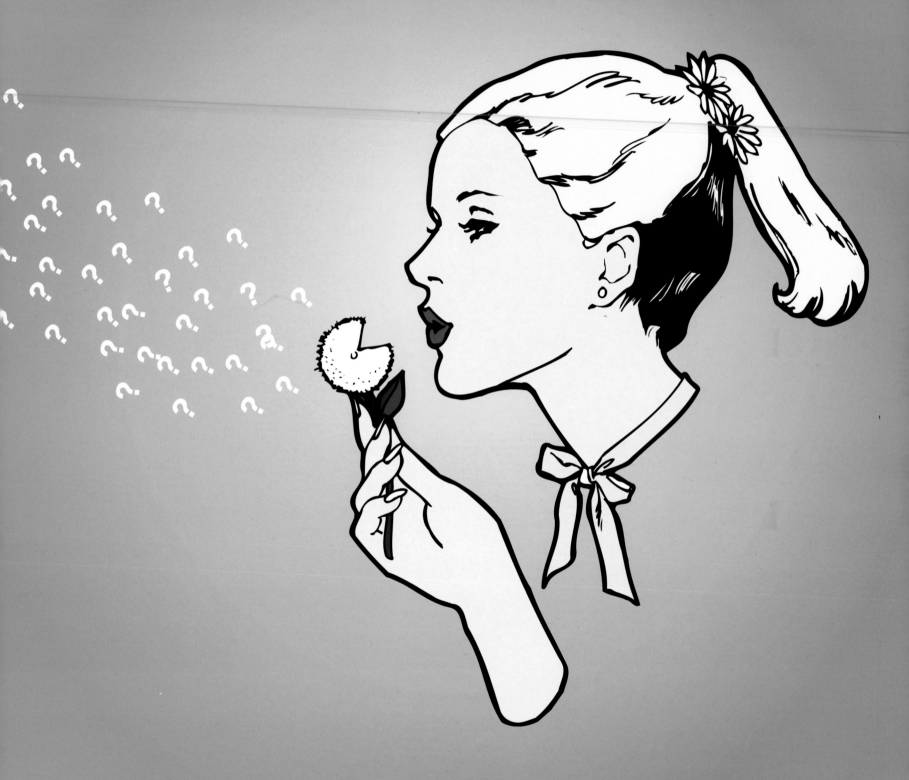

Donny Miller

You outgrow some people like an old hairdo.

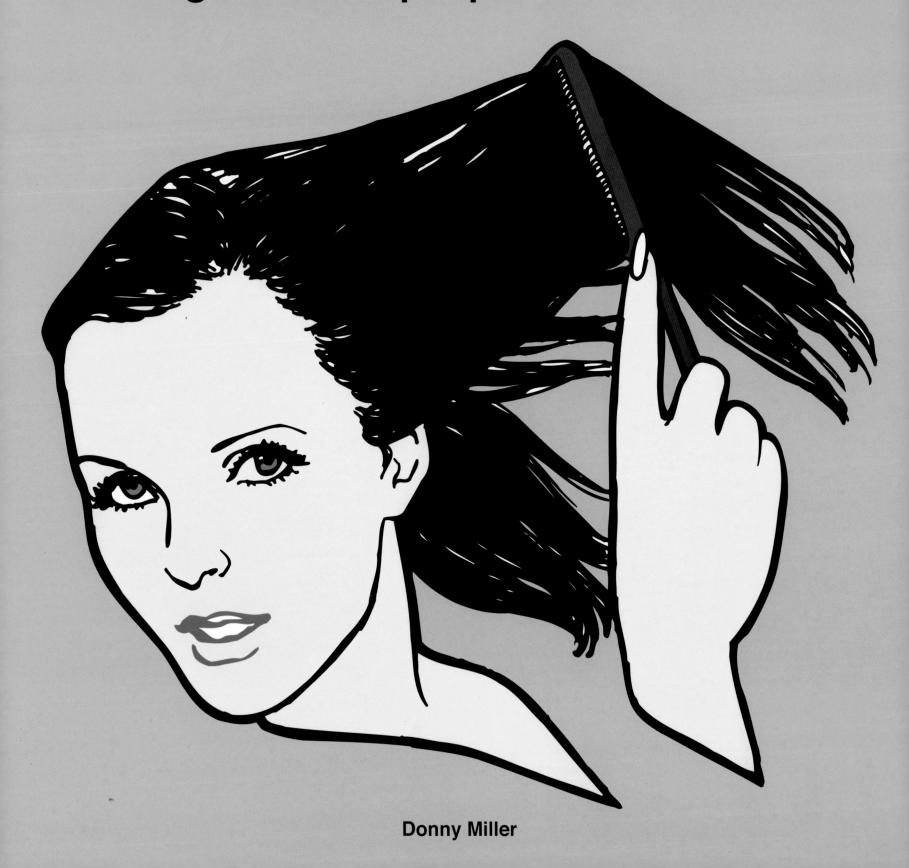

Donny Miller

I love your ability to seamlessly combine a compliment with an insult.

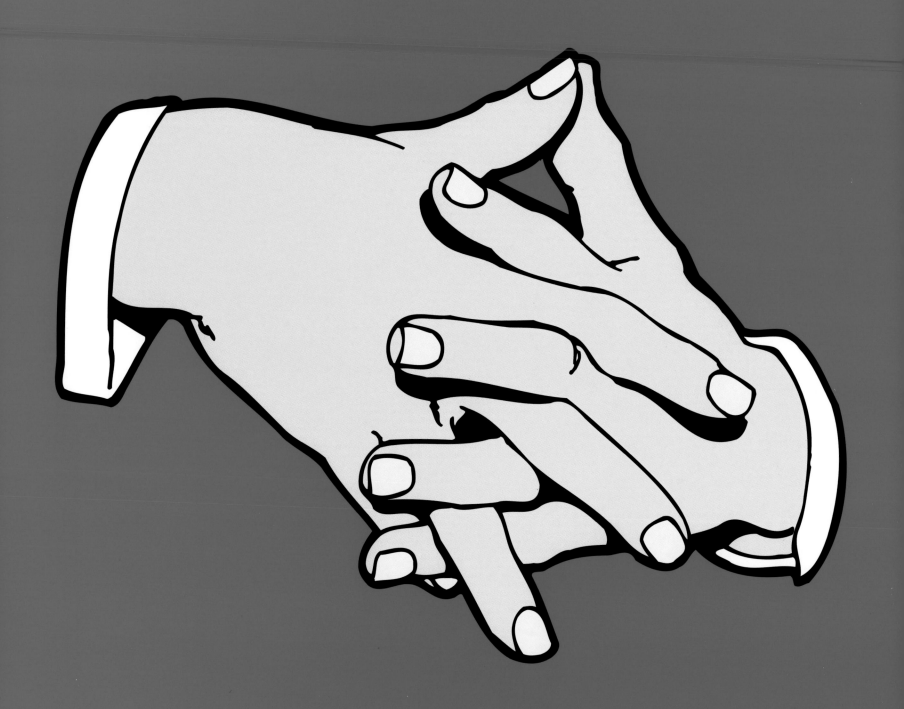

Donny Miller

I'm making new memories, because I don't like the old ones.

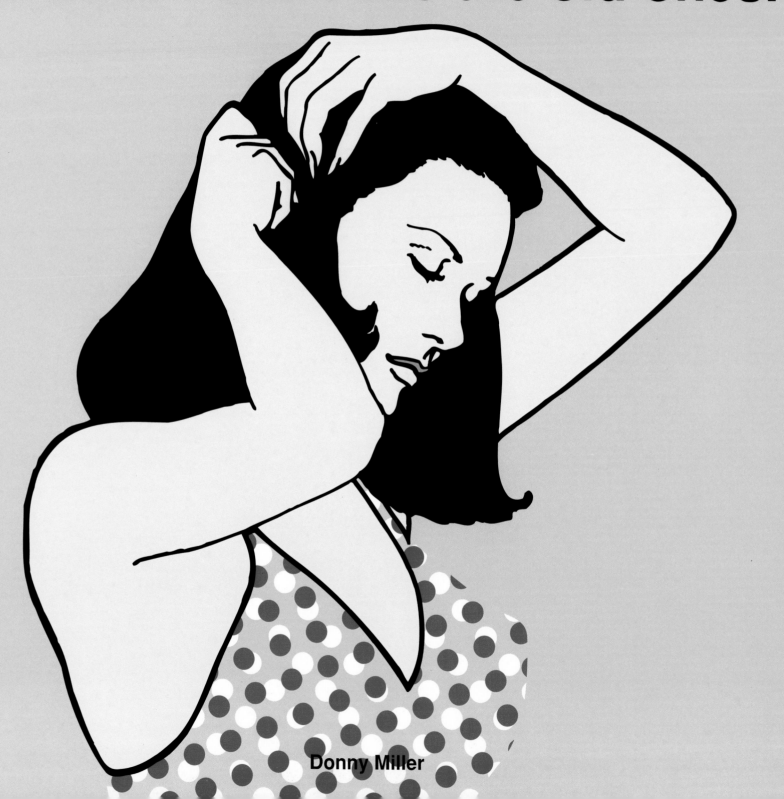

Donny Miller

Most people are half imagined and half real.

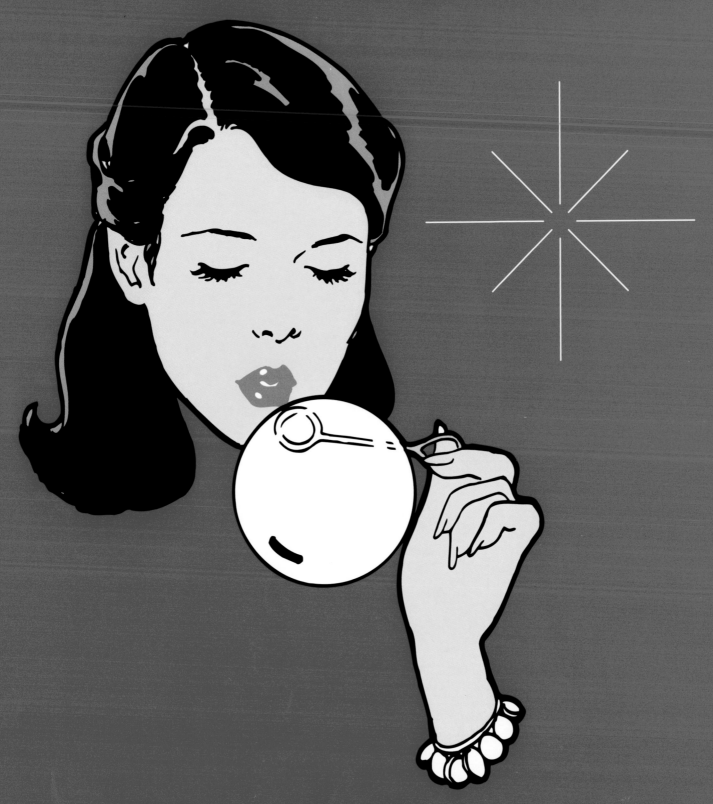

Donny Miller

I'm only arrogant because I'm afraid you'll find out I'm ordinary.

Donny Miller

Take these and make your life miserable.

Donny Miller

Nostalgia is his

tory with a sigh.

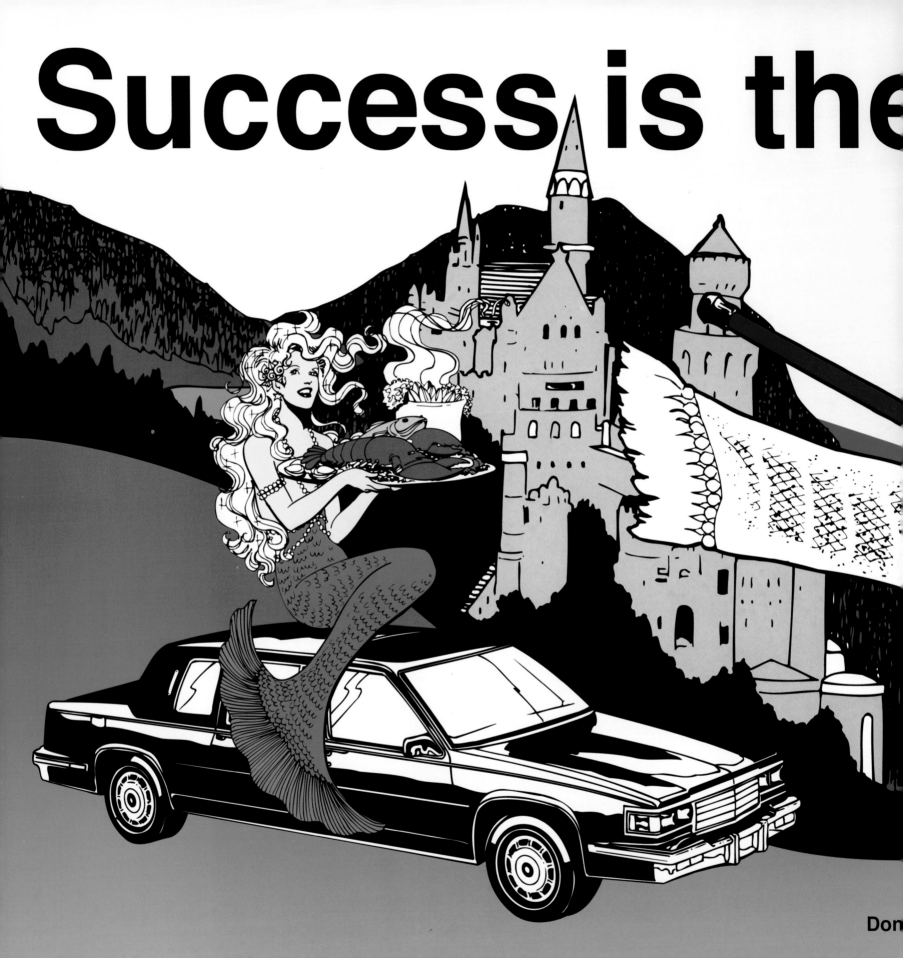

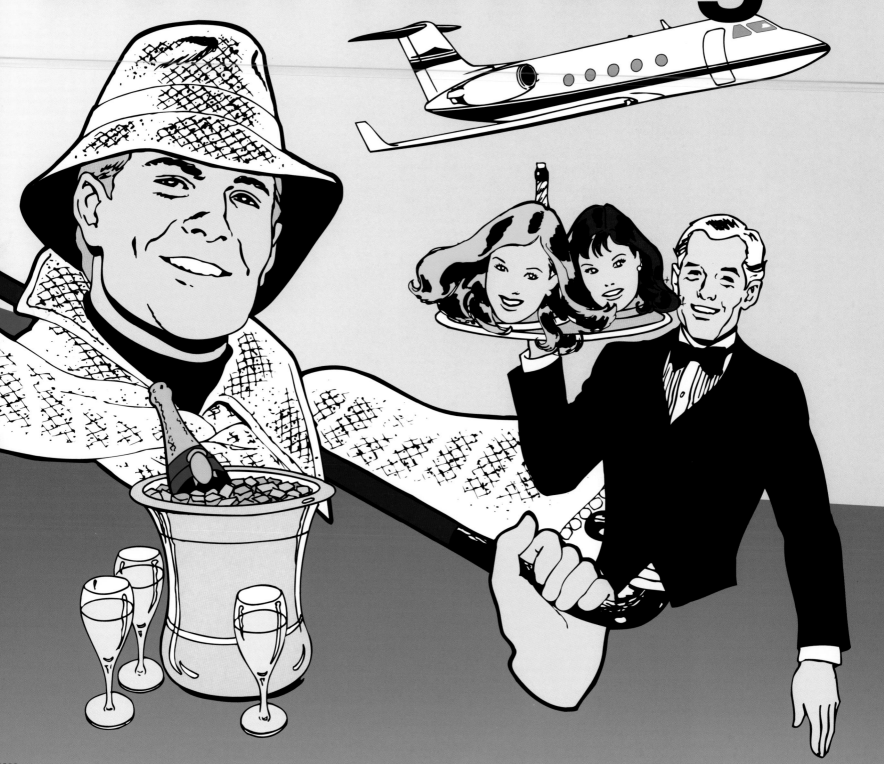

I wasted all my p

Don

etty years on you.

Maybe I like repeating the same mistakes over and over again?

Donny Miller

Of course I take everything personally. Who else matters?

Donny Miller

People need people because of other people.

Donny Miller

Maybe I don't have to be the victim this time.

Donny Miller

Have you ever been taken out of context?

Donny Miller

The world will keep turning no matter what you do.

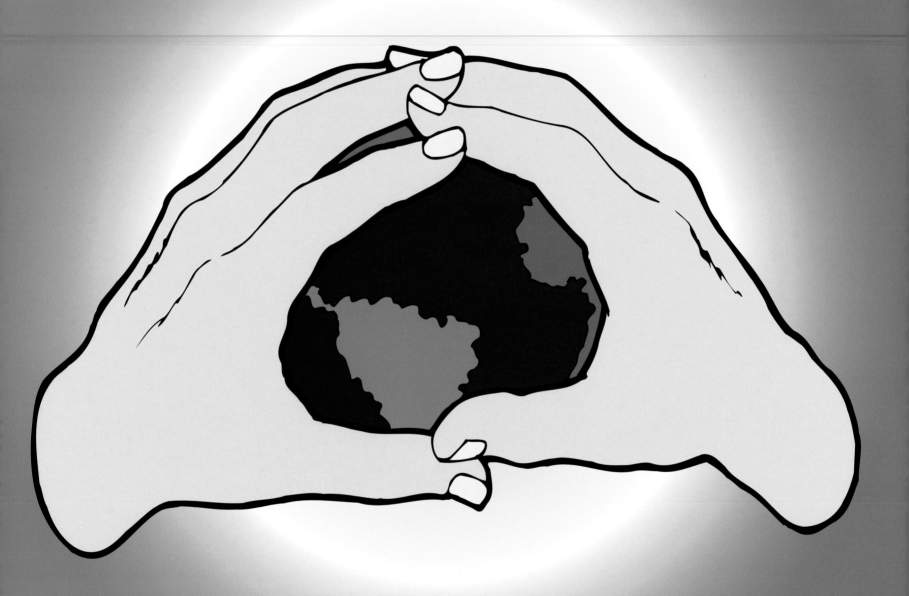

Donny Miller

I wish I was the one he was complaining about.

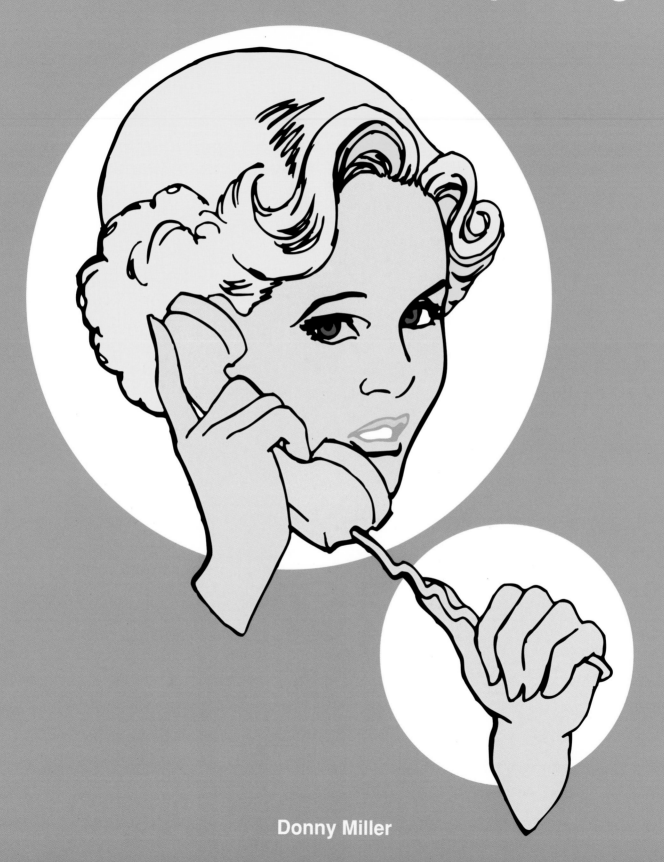

Donny Miller

**Everyone thought he was smart.
Turns out he was just really opinionated.**

Donny Miller

Politics is an old religion.

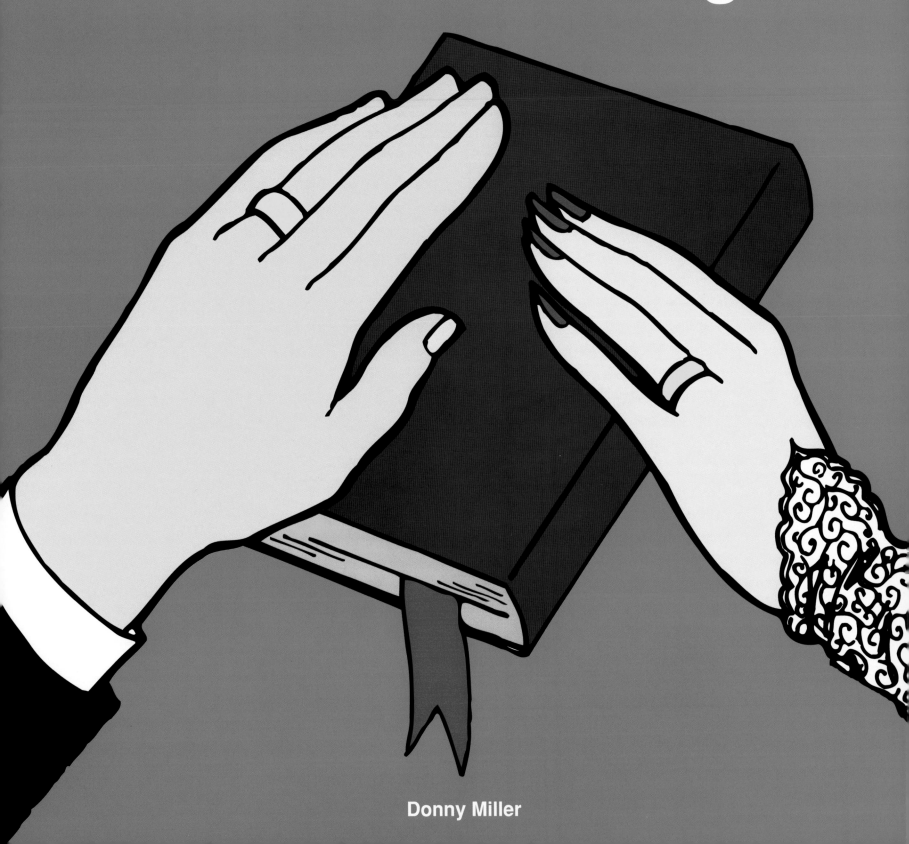

Donny Miller

Survival is selfish.

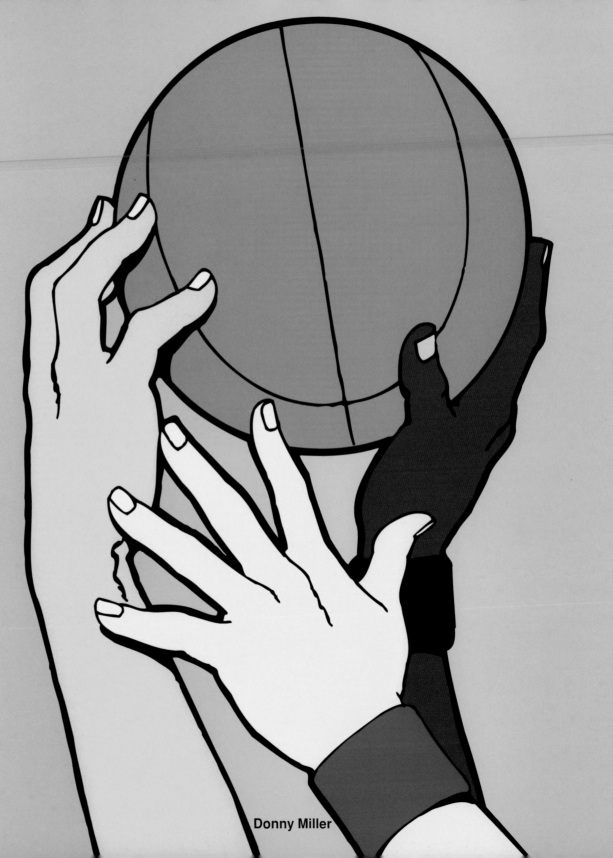

Donny Miller

Grandmother's wish to become a stuffed animal was finally realized.

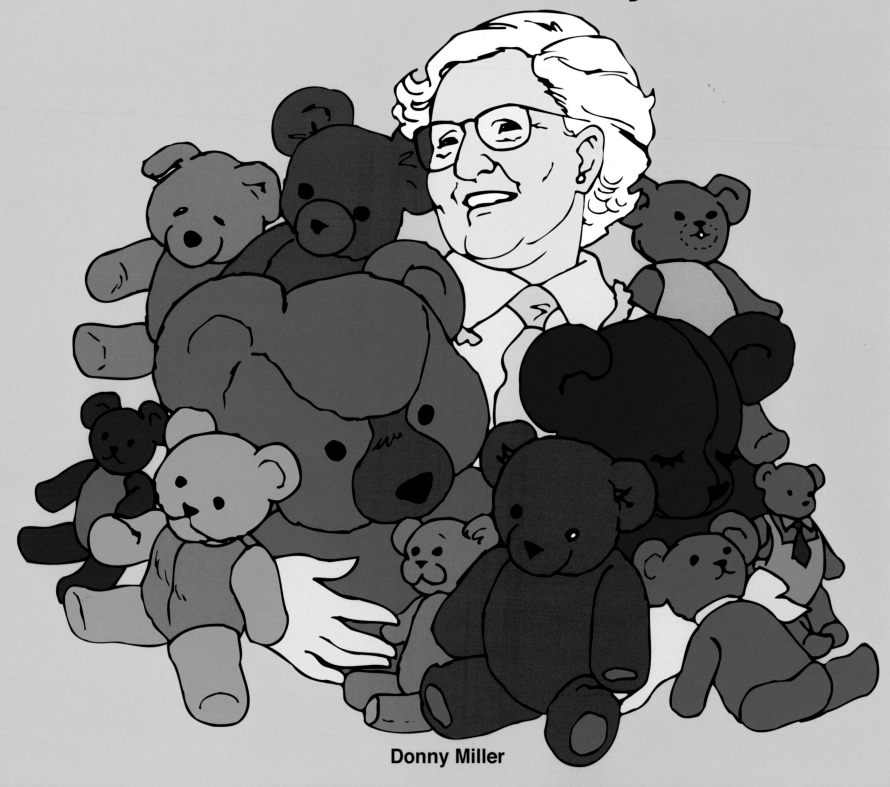

Donny Miller

Grandpa's new body is so tiny, but he's still a racist asshole.

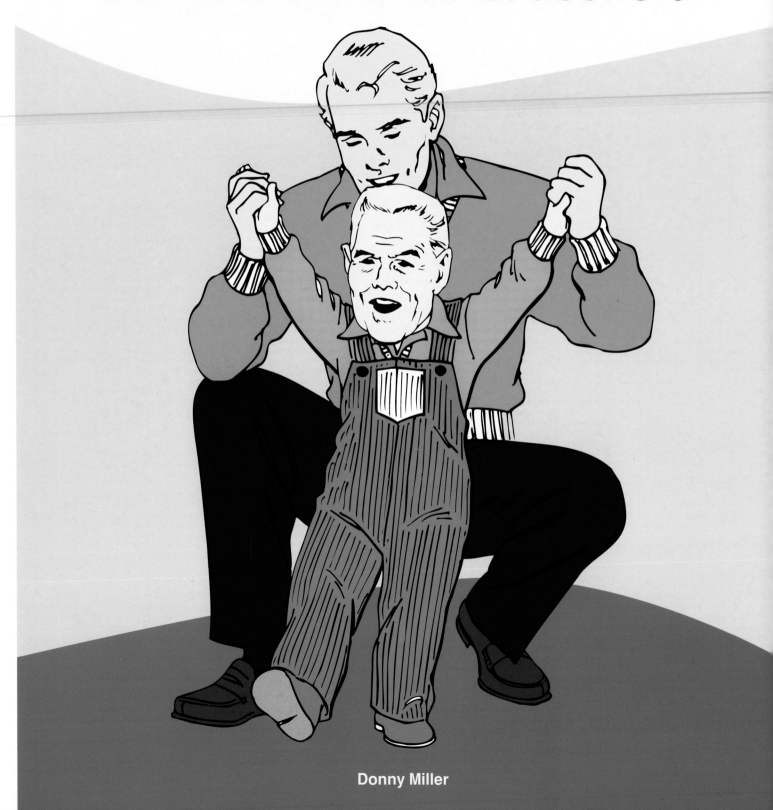

Donny Miller

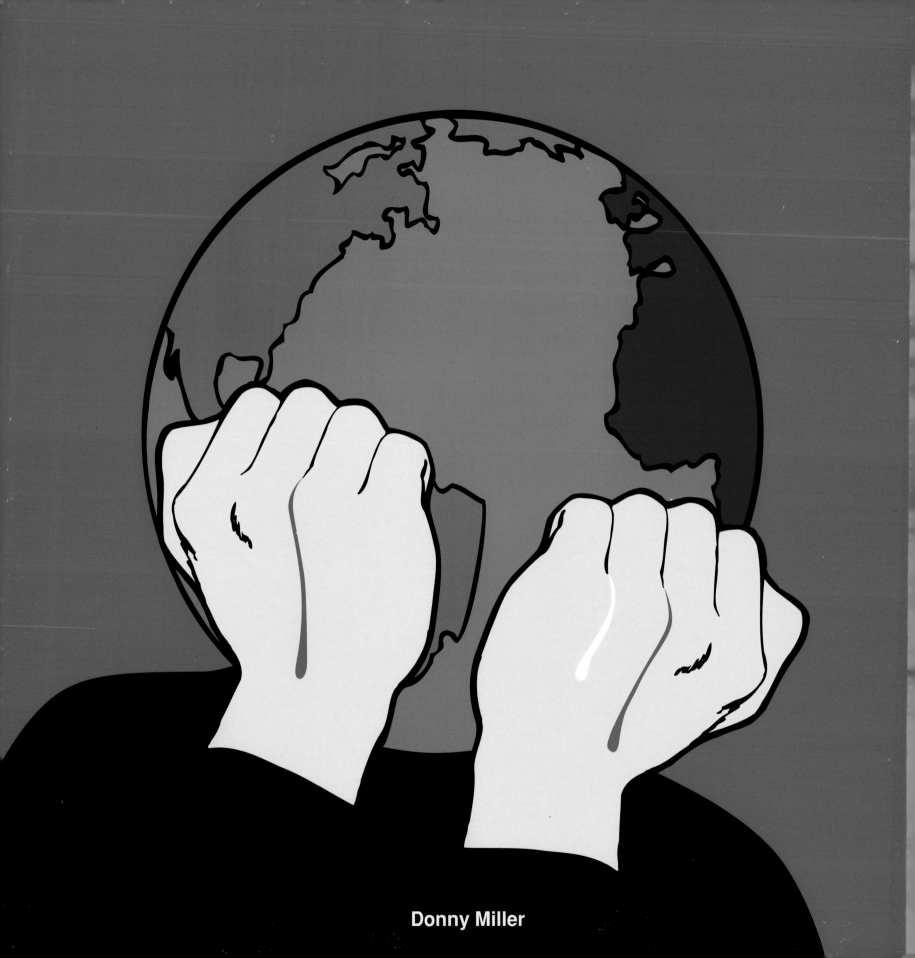

Donny Miller

The world doesn't terrify me. Just the people.

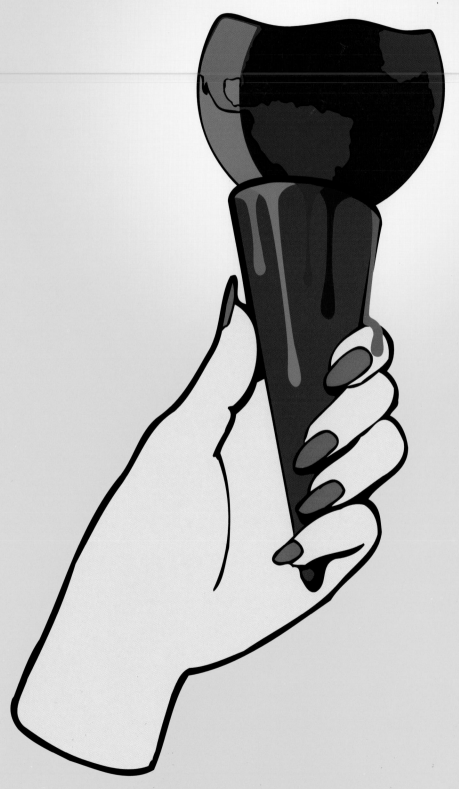

Donny Miller

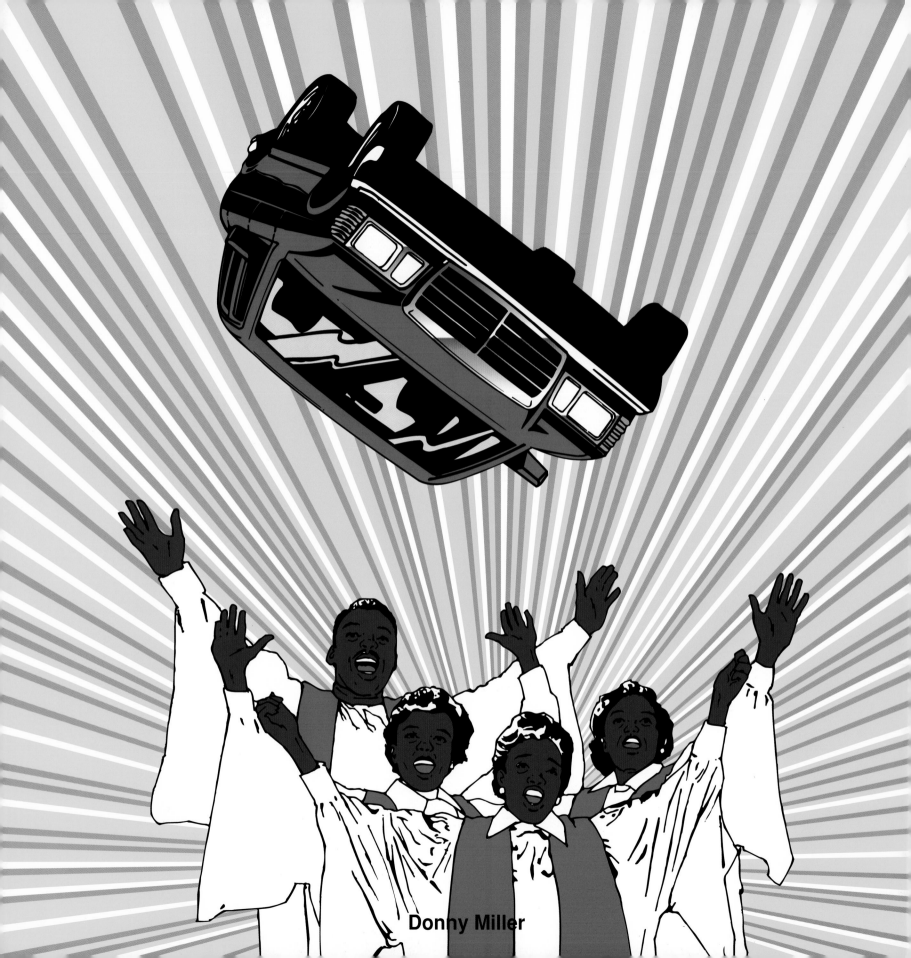

Donny Miller

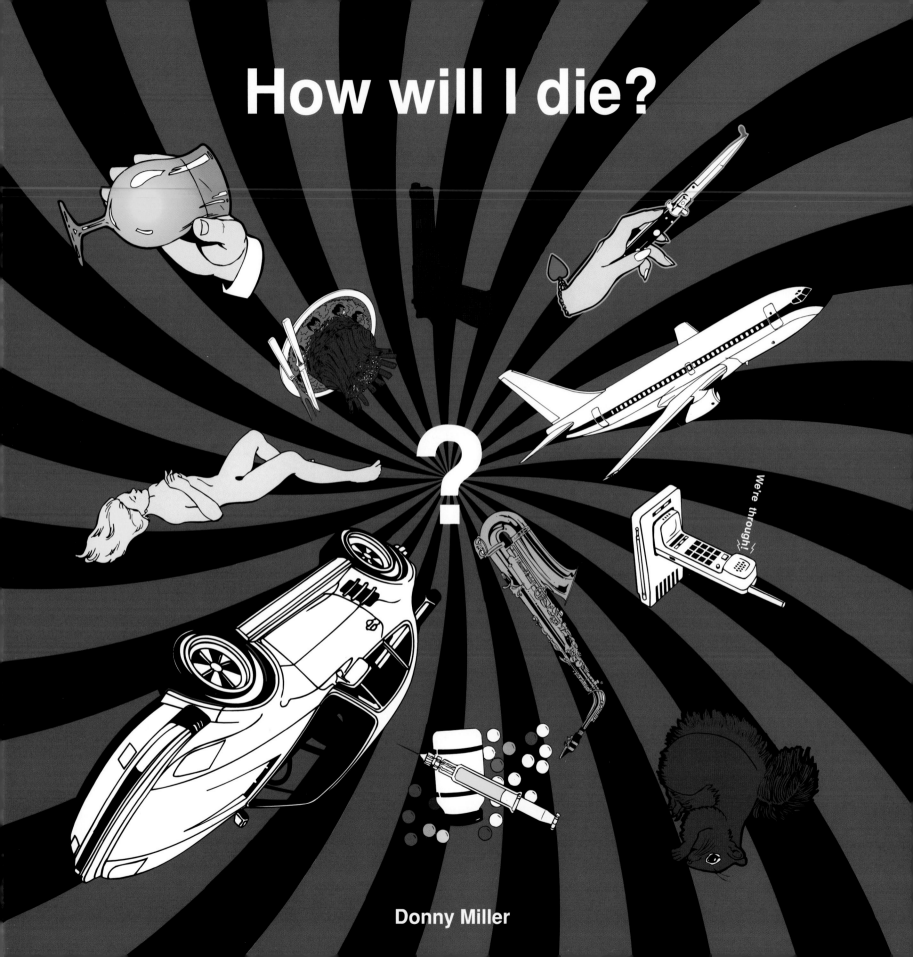

What will you be

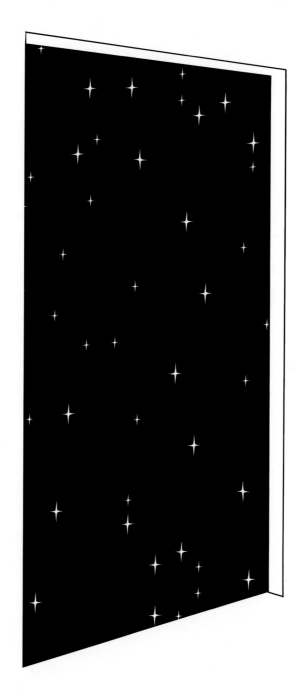

Donr

remembered for?

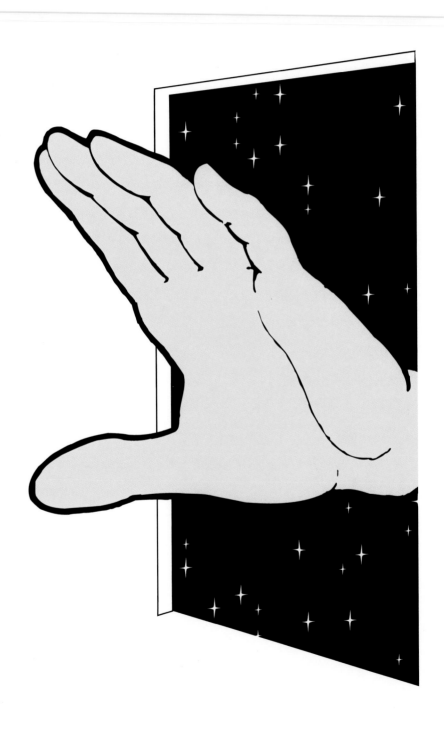

Miller

What do you think heaven is like?

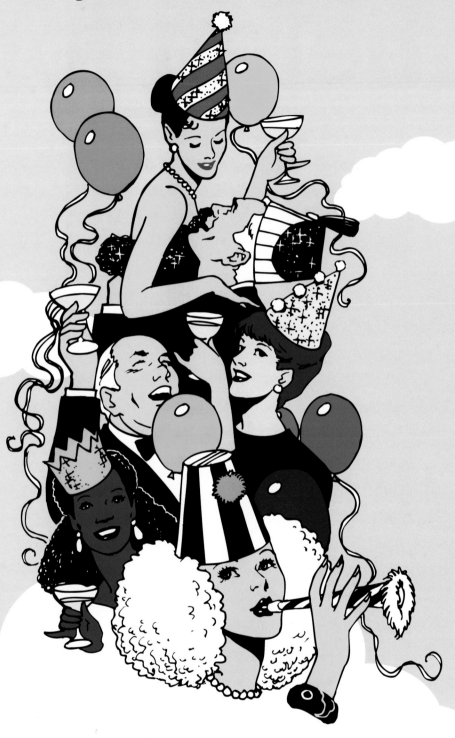

Me, too.

Donny Miller

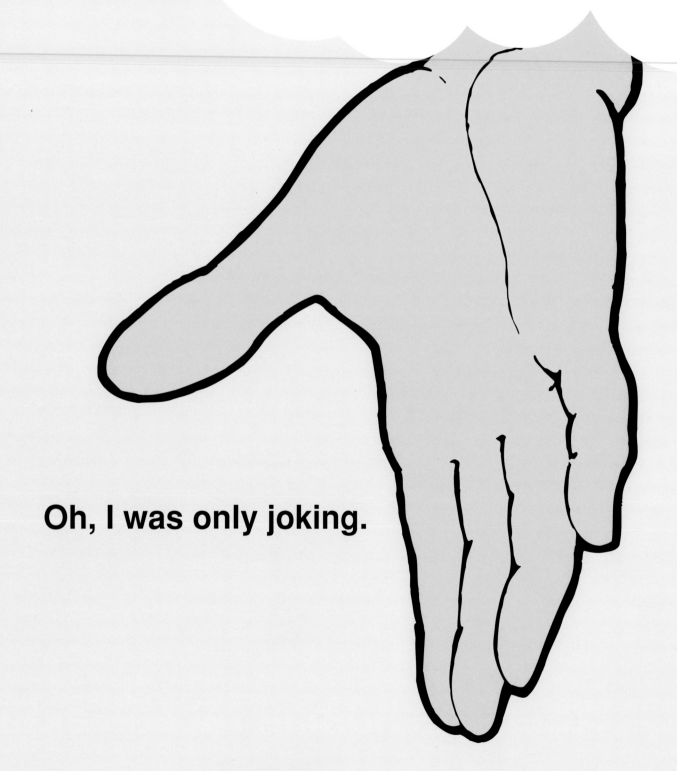

God, why is life so hard?

Oh, I was only joking.

Donny Miller

One day there will be peace on earth.

When the human race is extinct.

Donny Miller

Love is sharing a mutual contempt for the outside world.

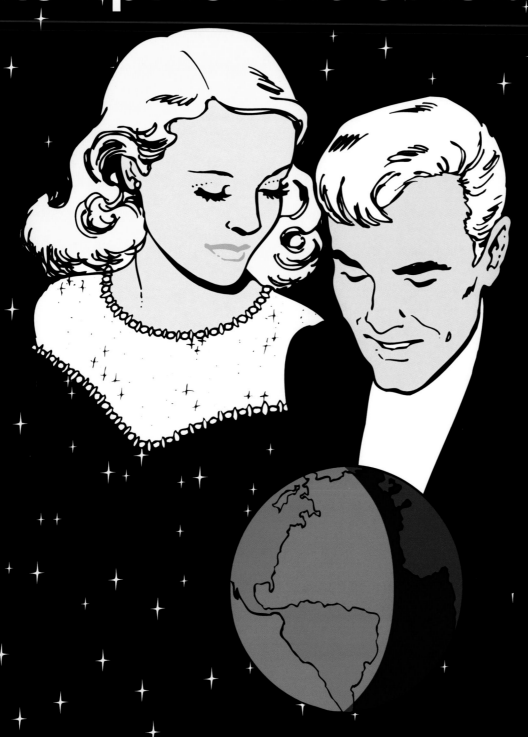

Donny Miller

The mind and the things we can do
with it are infinite.
There are so many places to go,
people to meet and things to think.
It's virtually endless, but here we
are thinking about ourselves.

–Donny

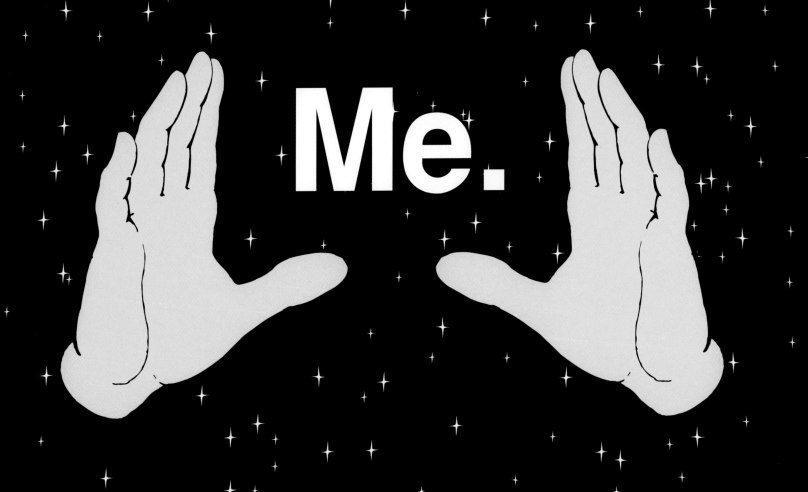